IMAGES
of America

HOWARD COUNTY

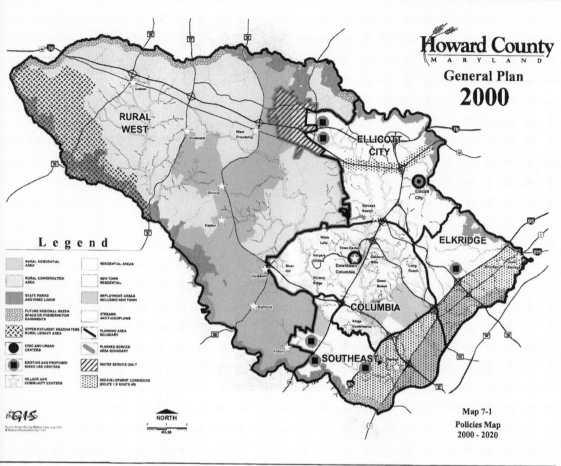

A FUTURE WITH A PAST. Howard is a county with one foot firmly planted in the past and the other striding confidently toward the future. While many of the magnificent manor homes have been lost to time and development over the years, many others have been rescued and lovingly restored. With a population approaching 300,000, Howard County's diverse range of citizens is among the best educated and wealthiest in the nation. (Courtesy Howard County government.)

ON THE COVER: THE IVORY POST OFFICE, MAY 20, 1886–FEBRUARY 15, 1918. According to local lore, when debating what to name the new Glenelg area post office, its first and only postmaster, shopkeeper William W. Sheppard, looked around his store. Upon spotting a box of Ivory Soap, he exclaimed to his wife, "Ivory! That is what we'll call it." (Courtesy Howard County Historical Society.)

IMAGES
of America

HOWARD COUNTY

The Howard County Historical Society
Foreword by State Senator Jim Robey

ARCADIA
PUBLISHING

Published by Arcadia Publishing
Charleston, South Carolina

Printed in the United States of America

Library of Congress Control Number: 2011920908

For all general information, please contact Arcadia Publishing:
Telephone 843-853-2070
Fax 843-853-0044
E-mail sales@arcadiapublishing.com
For customer service and orders:
Toll-Free 1-888-313-2665

Visit us on the Internet at www.arcadiapublishing.com

*With deep appreciation to all who have contributed to
and participated in collecting, protecting, and sharing the
fascinating photographic record of Howard County history*

CONTENTS

FOREWORD

Growing up during the 1940s in the small manufacturing town of Daniels, located on the banks of the Patapsco River, is one of my fondest memories. I don't think I really appreciated the relationship of the residents or an environment where one knew everyone in town. Outsiders considered us as economically disadvantaged because most did not own a car, we shopped at the company store, and our weekly rent was $3.50.

Daniels is part of the fabric and history of Howard County. Though the homes and company store are gone, and only parts of the factory remain, my wife and I still attend the Gary Memorial United Methodist Church, which has been the friendly church on Standfast Hill for over 130 years.

Looking back on my seven decades (that sounds better than 70 years), I often think of the special people who helped develop my character and love for this county. Obviously, my parents were first and foremost, but I still recall Omar J. Jones, my high school principal and the first Howard County executive; Sen. James Clark; retired police captain Jack Burke; and Herman Charity, the county's first African American police officer, as being mentors for me.

Many people, when asked about historic Howard County, will mention bricks and mortar sites—the Bollman Truss Bridge in Savage, the Thomas Viaduct in Elkridge, historical Ellicott City, Waverly Mansion, Troy Hill, and others. To me, the history of Howard County is reflected in the people who worked so diligently to develop what so many take for granted today. The quality of life, our acceptance of diversity, and our willingness to assist others make Howard County such a dynamic community.

—James N. Robey
Maryland State Senator

Future Howard County police chief, county executive, and Maryland state senator James N. Robey is pictured in his Howard County hometown of Daniels, Maryland, around 1942. (Courtesy James N. Robey.)

ACKNOWLEDGMENTS

As editor of a book that was researched, written, and reviewed during one of the most challenging and exciting years in the history of the Howard County Historical Society, I am grateful for the contributions and support of so many people who care so deeply about Howard County history. Chief among them is the author of this volume's introduction and my intrepid fellow photograph sleuth, Rebecca Reich, along with historical society volunteers Lee Owings Warfield III, Barbara Feaga, Phil Stackhouse, Jackie Mantua, Paulette Lutz, Karen Chapaleer, Connie Scholl, Gloria Barksdale Harver, Louis LeConte, and society executive director Lauren McCormack. Thanks also to Janet Kusterer, who provided information regarding our selection of Historic Ellicott City, Inc.'s (HEC), decorator show houses for our chapter "The Lovely Homes" and Maryland state senator James Robey, who so graciously agreed to share his fond memories of growing up in Howard County in our foreword. I and the historical society also owe a great debt to the extensive research and seminal works of local historians Joetta Cramm and Celia Holland, without whose works this book could not have been produced.

I also gratefully acknowledge the contributions of Helen Rushing and Galen Menne at the Savage Historical Society, as well as all the individuals who so generously opened up their homes, photo albums, and hearts to help in our endeavor. Last, but certainly not least, thanks to Arcadia Publishing acquisitions editor Elizabeth Bray, whose patience I am testing even as I write this acknowledgment. To those who doubted we could pull this off and to those who cheered us on, I say enjoy the fruits of a labor of love that I hope you will find as satisfying to read as it was to create.

Photographs that are part of the collection of the Howard County Historical Society are credited as (Courtesy HCHS.).

—Shelley Davies Wygant

INTRODUCTION

Howard County, Maryland, is a great place in part because of the many tangible reminders of its rich and culturally divergent past. Maryland is often described as a microcosm of the history of the United States, and the same could be said of Howard County. Even though Howard is one of the smallest of the counties, its history includes growth and development that rivals the early industry of New England and plays prominently in the birth of our great national transportation systems. Howard farmed innovatively, gave patriotic support during the world wars, and planned its growth to a 1960s ideal. The Howard County Historical Society (HCHS) is proud to present this brief historical synopsis of our shared heritage.

Geographically, Maryland's flat tidewater region meets with the rolling hills of the Piedmont Plateau, roughly along the corridor of US Route 1. This beautiful merging of geographical regions is expressed along the Patapsco River, where the land rises into a steep range of hills towering 300 feet above the river. Prior to European settlement, areas around the Patuxent and the Patapsco Rivers were home to the Algonquian people. The rushing waters of the river, the natural rise and fall of the land, and the thickly wooded forests made for ideal hunting and living.

The first European settlers arrived in Maryland in 1634 in what is today St. Mary's County. It is likely that settlers drifted into what is Howard County before the first land grant, which was issued to Adam Shipley in 1687. Parts of that original land grant are located near the intersection of today's Route 108 and Snowden River Parkway, where there is a commemorative road marker. The land granted to Charles Carroll (known as "the Settler") was patented in 1707 and consisted of over 10,000 acres, covering much of present-day Howard County.

It was during this period, from the late 1600s to the early 1700s, that Elkridge Landing became one of the busiest ports in Maryland (the city of Baltimore, founded in 1729, was just a small settlement), along with Bladensburg and Georgetown. Elkridge Landing was the farthest point inland that large, oceangoing vessels could navigate easily. Moreover, the banks of the Patapsco were full of minerals, and Elkridge was an early industrial site for mining and processing iron. Located along today's Race Road and Furnace Avenue are the remaining buildings of the furnace complex. Although no buildings from the 1700s remain, the c. 1835 landmark Elkridge Furnace Inn is one of the buildings that made up the Elkridge furnace complex, company store, and company dormitory. With the tobacco from the countryside and the iron ore industry, Elkridge Landing was a thriving community. Some other surviving structures of Howard's early history include the c. 1738 Belmont, the c. 1790 Ellerslie, and the c. 1730s Doughoregan Manor.

While Elkridge Landing was being surpassed by Baltimore due to the silting of the Patapsco River, in the 1770s the Ellicott brothers were searching for a site to establish a mill and make their fortunes. By 1771, they had reached the Patapsco Valley, and by 1774, they had constructed a mill to process wheat. The Ellicotts are important to history, not only because they are considered the founders of Ellicott City, but because of their influence on farming practices and the local transportation system. By the 1700s, the soils were depleted of nutrients because of tobacco planting. The Ellicotts persuaded local farmers to plant wheat, which would give the soil a chance to rest. The Ellicotts also learned to fertilize the soil using ground plaster. Most notably, they persuaded Charles Carroll to switch from tobacco to wheat. It was the relationship between Carroll and the Ellicotts that resulted in the construction of the road between Doughoregan Manor and Ellicott City. This eventually became part of the path of the National Road and is today's Route 144.

Ellicott City was not the only burgeoning industrial area in the county. Nearby, on the banks of the Little Patuxent River, the Savage Manufacturing Company purchased property and erected

a textile factory in the 1820s. The oldest buildings in the mill complex that remain today include the stone carding and spinning building. It was constructed around 1823 and originally housed all of the factory's activities.

The Ellicotts and the Carrolls were not the only families who benefited from the construction of a road between points west and Ellicott City. The national movement of westward expansion was upon the nation. In 1805, the State of Maryland commissioned the Baltimore-Fredericktown Turnpike Company to construct, maintain, and collect tolls on the 62 miles of road between Baltimore and Boonsboro. Company president Jonathan Ellicott was instrumental in forming three other turnpike companies that extended the road to Cumberland, where it met with the federally funded National Road in 1818. This made it possible to travel overland between Baltimore and St. Louis. Ellicott City was a favorite stopping point for travelers to rest and refuel, as were Lisbon and Poplar Springs.

Equally exciting was the construction of the Baltimore and Ohio Railroad (B&O), which began in 1828 when Charles Carroll performed the ground-breaking ceremony. The first section was completed in 1830, and the first train rolled into Ellicott Mills (Ellicott City) on May 24, 1830. Over time, the rail corridor was built to follow the Patapsco River to a point in Parr's Ridge (Mount Airy), where the tracks would then cross a height of land and descend into the Monocacy Valley. The final terminus, in Wheeling, West Virginia, was complete in 1853. A spur of the main line was constructed to connect Baltimore to Washington, DC. The main line split at Relay, where the rail would cross the Patapsco River on the Thomas Viaduct (completed in 1835), which remains in use and is one of the signature structures of the B&O. Designed by Benjamin H. Latrobe II (son of Benjamin H. Latrobe, architect of the United States Capitol and the Basilica of the Assumption), the Thomas Viaduct was the first multi-span masonry railroad bridge in the United States and the first to be built on a curving alignment. It was the largest bridge in the country in its day.

While industrial growth maintained a steady pace in Ellicott City and other points along the Patapsco (as well as in Savage on the Patuxent), smaller communities also sprinkled the county, including West Friendship, Poplar Springs, Glenelg, Tridelphia, Florence, Glenwood, Oakland Mills, Clarksville, Annapolis Junction, Scaggsville, Highlands, Guilford, Jonestown, Dayton, and others. While each of these communities has a distinct heritage and story to share, the agricultural industry of Howard County grew in a similar fashion to the surrounding counties—from subsistence farming to larger scale production. With the introduction of the pasteurization process, milk could be stored longer and shipped farther away, and some farms started to specialize in dairy production. Other farms continued to grow a variety of vegetables to sell to canning factories near Annapolis Junction or just over the county line in nearby Carroll County.

While fires and floods destroyed much of Ellicott City's manufacturing industry in the 19th century, the rest of the county continued to farm. Ellicott City, Savage, and Elkridge took backseats to other industrial areas. Life and time stops for no one, but the early part of the 20th century was a period of slow growth for Howard County. Families did what they could to aid in the efforts of World War I, and boys quickly became men as they went off to war. Howard County was hit by the national flu epidemic of 1918, felt the devastating effects of the Depression coupled with a drought in 1930, and yet still found time to enjoy picnics, horse shows, and traveling entertainment. A new business that thrived during this period was the sale and maintenance of the automobile. During World War II, the county was busy with defense activities. These included the Women's Council of Defense; draft registration; collection efforts for newspapers, metal, and rubber; growing victory gardens; and participation in regular air raid drills. Many Howard County farmers were able to use German prisoners of war, who were trucked in from where they were being held at Fort Mead, to work on their farms.

After World War II, Howard County began to feel the effects of the national suburbanization movement. Early suburban neighborhoods were built for incoming industries, such as the Applied Physics Lab and Westinghouse. With continual improvements to the transportation system, commuting to either Baltimore or Washington, DC, became possible.

Undoubtedly, the largest impact of the suburbanization movement in Howard County was the founding of the town of Columbia. James Rouse, through a series of real estate transactions, amassed 14,000 plus acres to develop this planned community. Rouse and his designers first presented a development proposal to citizens in 1963. By 1965, approval was granted, and by 1967, the first residents of Columbia moved into their new homes.

Howard has been able to embrace suburban growth while trying to maintain some of the beautiful rolling countryside of the western part of the county that is so reminiscent of bygone days. Ellicott City, Savage, Elkridge, and Laurel are teaming with older buildings, and gracious homes dot the county. This book contains but a sampling of Howard County's rich heritage and history.

—Rebecca Reich

One

OUR HISTORY

THE LAND THAT
CHANGED HANDS.
The land that makes
up Howard County's
251 square miles was
originally part of Anne
Arundel County. In 1659,
the assembly ceded it to
Baltimore County. In
1726, it was returned to
Anne Arundel County.
In 1839, it became
the Howard District
of Anne Arundel,
and in 1851, Howard
County became an
independent jurisdiction.
(Courtesy HCHS.)

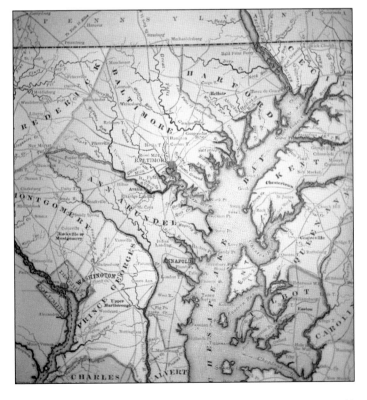

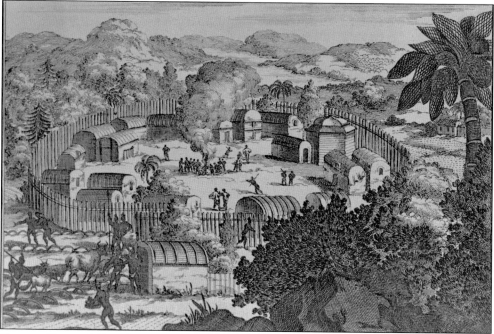

HOWARD COUNTY'S FIRST INHABITANTS. The Native Americans that Capt. John Smith encountered in 1608 when he sailed up the Patapsco were Algonquians. Hunters of plentiful elk, black bear, bison, turkey, rabbit, and deer and fishers of herring, shad, and rockfish from the Patapsco River, Howard's original inhabitants most likely lived in small dwellings covered with bark and rush mats in stockaded villages, such as the Susquehannock encampment pictured above. (Courtesy Maryland Historical Society.)

VIEW OF PATAPSCO RIVER, 1886. The Patapsco River, which got its name from the Algonquian word for "backwater" or "tide covered with froth," forms the county's northern border. Early settlers built iron furnaces at Elk Ridge Landing at the mouth of the river and then moved upstream to build gristmills at Ellicott's Mills. Productive and destructive, the river fueled the valley's industrial revolution and wreaked havoc during frequent floods, including the disasters of 1868 and 1972. (Courtesy HCHS.)

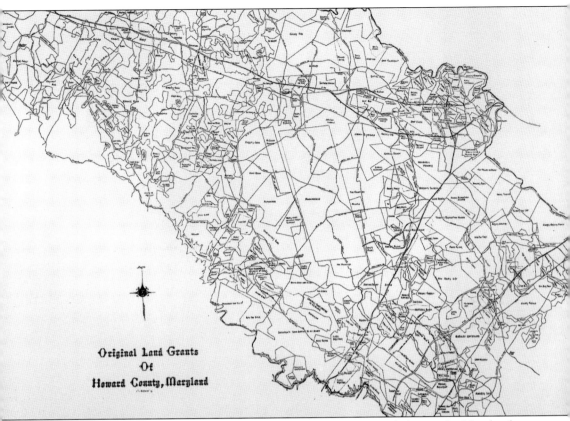

Original Land Grants
Of
Howard County, Maryland

LURED BY LAND GRANTS. Charles I of England granted the original charter for Maryland to Cecilous Calvert, the second Lord Baltimore, in 1632. The Calverts recruited Catholic aristocrats and Protestant settlers from England, in part by offering them generous land grants. The largest land grant, 7,000 acres, was called Doughoregan and was patented by Charles Carroll in 1702. The smallest was the one acre Find It If You Can, which was patented by Charles Welsh in 1767. Many patentees gave their grants fanciful names, including Kings Contrivance, Bachelor's Choice, Ranter's Ridge, Lost by Neglect, Break Neck Hill, Long Reach, and Chews Vineyard, some of which have become names of Columbia's villages. Dr. Caleb Dorsey, who spent nine years researching early patent information at the hall of records in Annapolis, in 1968 completed the first and only map showing all 359 of the county's original land grants. (Courtesy HCHS.)

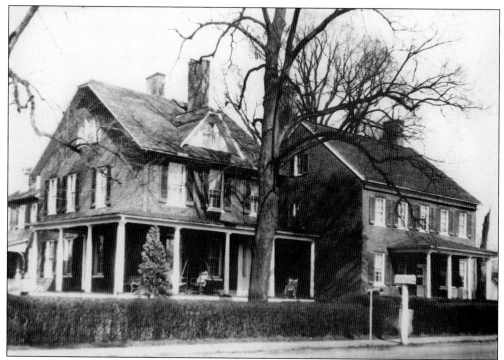

ELK RIDGE LANDING. In 1743, Caleb and Edward Dorsey were granted patents to Elk Ridge Landing on the highest navigable point of the Patapsco. In 1755, the Dorseys established Elk Ridge Furnace, an enterprise that over the next century or so would grow into a complex of industrial buildings and homes, two of which have survived to the present and now welcome guests as the Elkridge Furnace Inn. (Courtesy HCHS.)

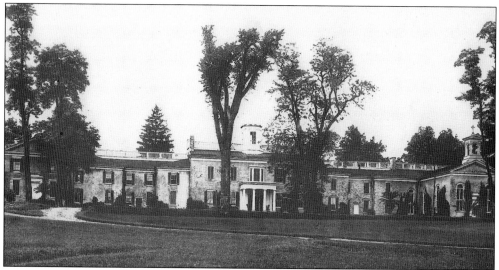

DOUGHOREGAN MANOR. Started in the early 1700s and finished in 1830, this landmark Greek Revival manor was home to Charles Carroll of Carrollton, one of the signers of the Declaration of Independence. An early convert from tobacco to wheat farming, Carroll helped fuel the success of the grain milling operations in Ellicott's Mills and prompted the Ellicotts' construction of Frederick Road, the county's first major roadway. (Courtesy HCHS.)

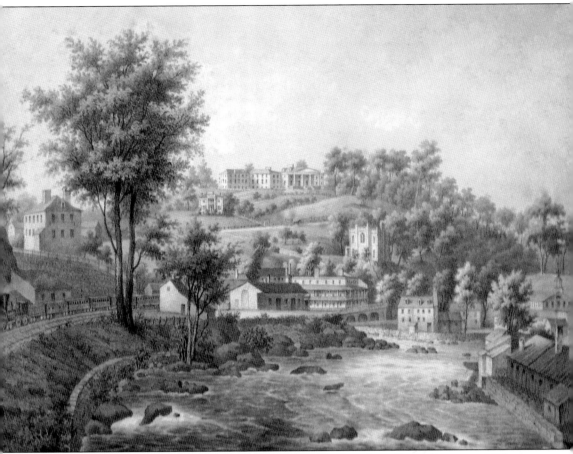

THE FOUNDING OF ELLICOTT'S MILLS. In 1772, three Quakers from Pennsylvania established a flour mill at "the Hollow" along the Patapsco that would grow into the prosperous city depicted in this E. Sachse & Company lithograph. Based on *A Drawing from Nature*, which was executed in 1857 by Patapsco Female Institute professor of fine art Charles Koehl, this work highlights many of the town's landmarks, including the Patapsco Female Institute, the picturesque Castle Angelo, the B&O Railroad Station, and the Patapsco Hotel. All of these structures continue to grace the town's cityscape in some form today. (Courtesy Drs. James C. and Mary G. Holland.)

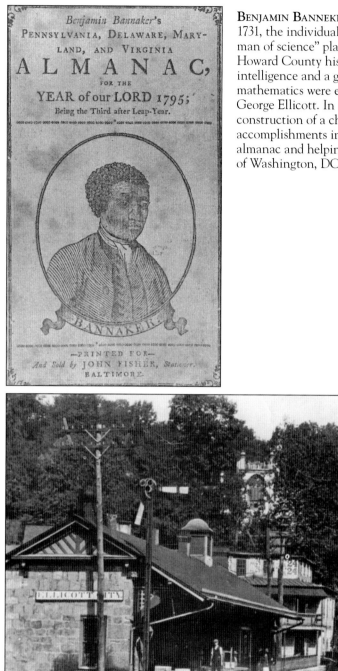

BENJAMIN BANNEKER. Born in Oella about 1731, the individual known as "the first black man of science" played an important role in Howard County history. His gifts of natural intelligence and a genius for mechanics and mathematics were encouraged by his friend George Ellicott. In addition to his self-taught construction of a chiming clock, Banneker's accomplishments included publishing an almanac and helping to survey the boundaries of Washington, DC. (Courtesy HCHS.)

AMERICA'S FIRST RAILROAD STATION. Built in 1831 from locally quarried granite, B&O Railroad's Ellicott's Mills Station was the terminus of the first 12 miles of commercial railroad track laid in America. It is the oldest passenger station in the world. Because it was originally built to service trains and house freight, early passengers waited for their trains in the comfort of the Patapsco Hotel across the Oliver Viaduct. (Courtesy HCHS.)

THE LEGEND OF TOM THUMB. The famous 1830 race between the Tom Thumb steam engine and a horse supposedly took place on the new railroad tracks between Ellicott's Mills and Baltimore. However, according to research done by *Baltimore Sun* reporter Frederick Rasmussen in 1980, the race probably never took place. Still, the legend lives on in storybooks and this replica that rode the rails in Ellicott City during a commemorative celebration. (Courtesy HCHS.)

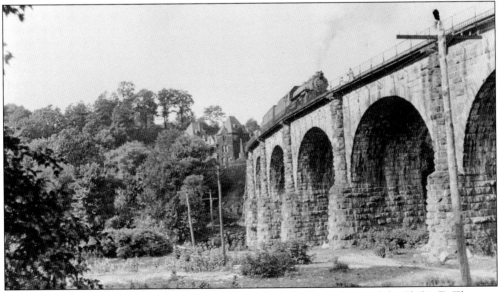

THOMAS VIADUCT. Designed by Benjamin Henry Latrobe Jr. and named for Philip E. Thomas, the first president of the B&O Railroad, this 700-foot-long structure was built to extend the railroad line from Baltimore to Washington, DC. Begun in 1833 and completed in 1835 at a cost of approximately $150,000, it is the oldest multiple-arched stone railroad bridge in the world. It is still in use today. (Courtesy the Smithsonian Institution, HAER MD, 14-ELK, 1-18.)

SITE OF CAMP JOHNSON, 1862. In the fall of 1862, nearly 1,000 troops of the 12th New Jersey Volunteers stood guard over Ellicott's Mills at Camp Johnson, located either near the courthouse or above the Patapsco Female Institute, pictured here. In a letter home, Sgt. Charles Lippincott wrote, "I believe I've never seen a place quite so hilly as this" and "there's just room on the top for our tents." (Courtesy HCHS.)

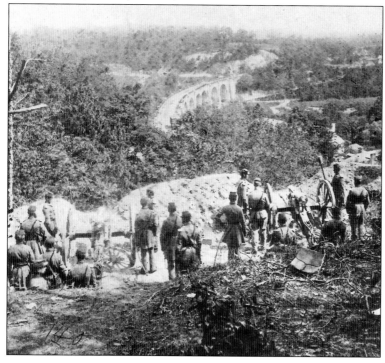

FEDERAL TROOPS AND THE THOMAS VIADUCT, 1861. During the Civil War, Union troops stationed themselves at various places in largely secessionist Howard County, including at the Thomas Viaduct, where they were positioned to protect the railroad bridge from Confederate sabotage. (Courtesy Western Reserve Historical Society.)

ROBERT E. LEE VISITS LINWOOD. His first visit was in the early spring of 1860, when Lee was a colonel in the 2nd United States Cavalry. His second visit was in July 1870, while he was in the area to see a specialist in Baltimore about his rheumatic condition. Both times, he stayed at Linwood, the Ellicott City home of his wife's first cousin George Washington Parke Custis Peter. Located at the end of Church Road, this immense granite house started out in the 1780s as only a small home. Over the years, it expanded into a grand mansion that boasted 17 rooms, a great hall, and a magnificent spiral stairway rising from the first floor to the attic. Today, it stands substantially altered, both inside and out, as the Linwood Center. (Both, courtesy HCHS.)

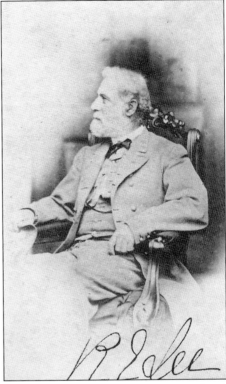

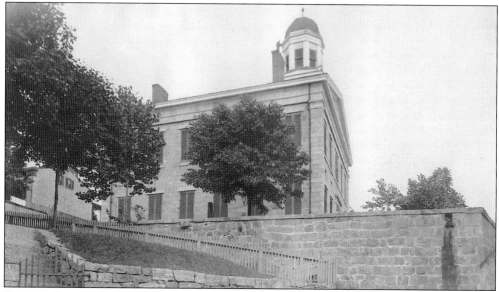

HOWARD COUNTY COURTHOUSE. Designed and built by Charles Timanus between 1840 and 1843, the Classical Revival Howard County Courthouse, seen in this c. 1915 photograph, took more than two years to build because of the difficulty of hauling the locally quarried granite to the top of what was known as Capitoline Hill. (Courtesy HCHS.)

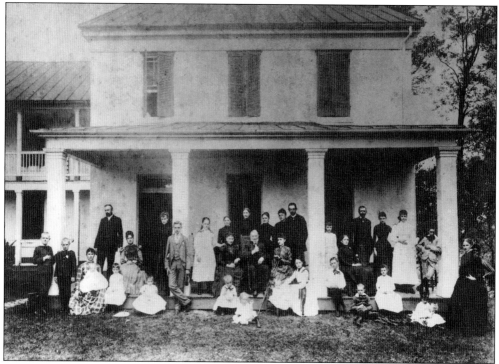

THE CLARKS AT WHEATFIELD, 1889. The late 1800s were prosperous times during which a number of prominent families grew and made their mark on county history. Here, all 34 descendants of James Clark (center with beard) gather on the steps of Wheatfield to celebrate his 80th birthday. This 1850s-era home still stands off Montgomery Road east of Route 29. (Courtesy HCHS.)

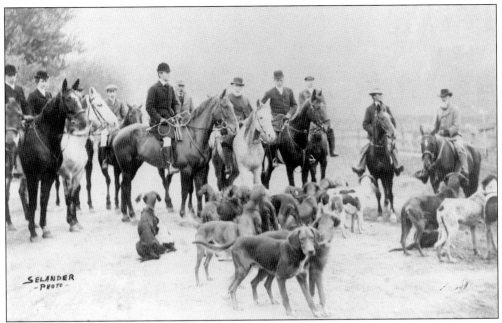

PATAPSCO HOUNDS, 1900S. Fox chasing was a favorite pastime of the landed gentry, from the late 1800s onward. Here, Fanny Lurman, master of the hounds Dorsey Williams, Napolean Dorsey, Atwood Blunt, Bradly Blunt, and Pulaski Dorsey gather with the hounds at Charles Carroll's Homewood estate. The lineage of these canines could be traced back to 1814 to a pair of Irish foxhounds, which belonged to the Duke of Leeds and made their way into the possession of Charles Carroll. (Courtesy HCHS.)

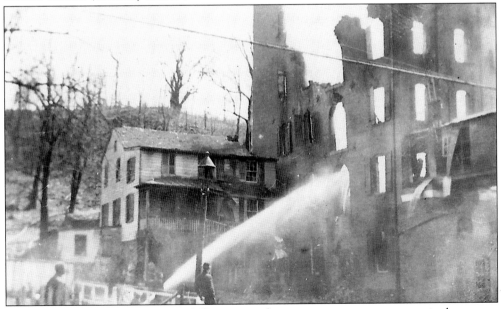

PATAPSCO FLOURING MILL FIRE, 1916. Devastating fires were a common occurrence in the county. This one began on the morning of April 19 at about 5:00. The cause was suspected to be a spark caused by the friction of running the milling equipment virtually around the clock in order to fill orders for the Allied forces during World War I. (Courtesy Weld-Keller family.)

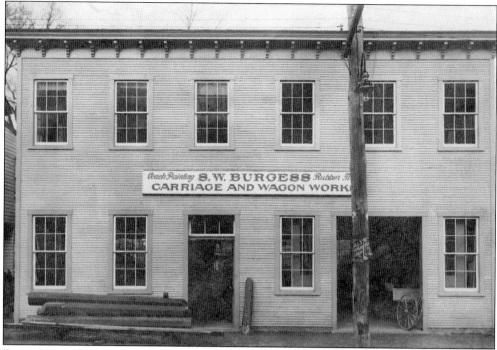

FROM CARRIAGES TO CARS. In business as a carriage and wagon works from June 1906 until January 1917, when it switched over to being an auto sales and service enterprise, the S.W. Burgess company on Main Street in Ellicott City kept vehicles of all sorts in working order as the county moved into the modern age. (Courtesy HCHS.)

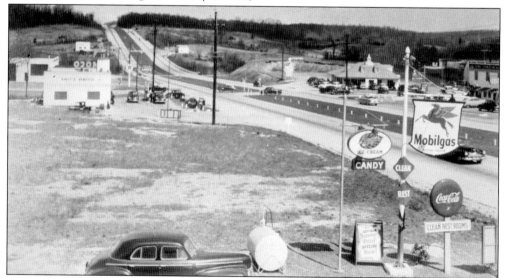

THE NEW ROUTE WEST. When automobiles became popular in the early 20th century, Americans pressed for the construction of transcontinental highways. During the 1920s, the federal highway system was formed, and plans were drawn for Route 40, a coast-to-coast highway that would run straight through northern Howard County. Gas stations, motels, and diners, including the Mobil gas station and the Pig 'N' Whistle Drive-In seen here at the upper right, soon sprang up along the road to accommodate the new trade. (Courtesy HCHS.)

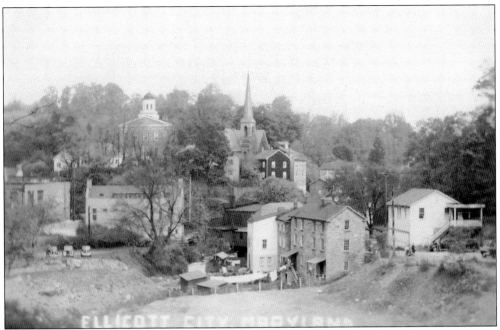

TOUGH TIMES. The 1930s and 1940s were a time of hardship and sacrifice. German prisoners of war were trucked in to help out on farms. Victory gardens sprang up in backyards. Food and gas rationing were in effect. Ellicott City slid into such a decline that it was declared off limits to soldiers at Fort Meade because of the overabundance of bars and "loose women." (Courtesy HCHS.)

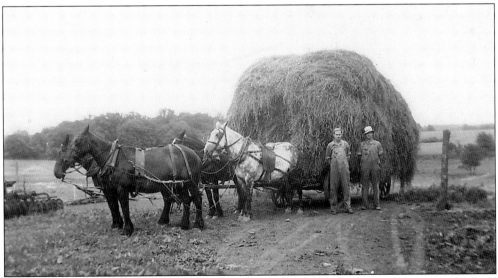

DOWN ON THE FARMS. Large family-owned farms continued to dominate the landscape through most of the 20th century. Ridgely Jones, pictured with his hay wagon in this 1930s-era image, numbers among the 10 generations to have farmed Bowling Green from when it was established in the 1700s until the present day. (Courtesy Ridgely Jones family.)

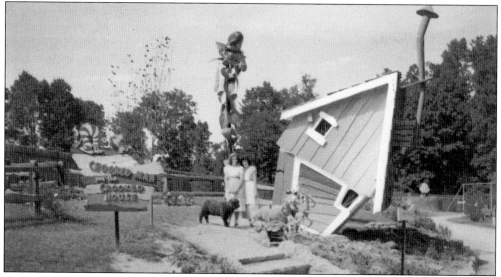

ENCHANTED FOREST. Envisioned as the East Coast's answer to Disneyland, the fairy-tale themed Enchanted Forest opened on August 15, 1955—one month after Disneyland. Admission was $1 for adults and 50¢ for children. Initially situated on 20 acres west of Ellicott City on Route 40, the park later expanded to 52 acres. At the height of its popularity, it welcomed 300,000 children each summer season. (Courtesy HCHS.)

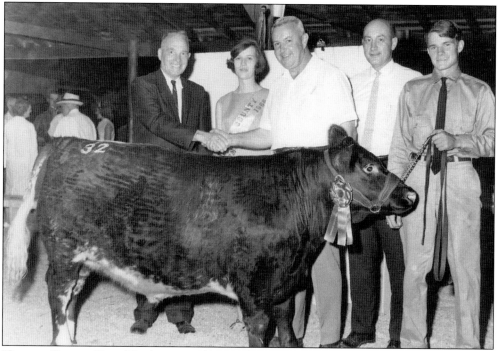

HOWARD COUNTY FAIR. The first annual Howard County Fair was held in August 1946 at Brendel Manor Park. In 1947, the fair moved to the grounds of the Ellicott City High School. Admission cost was 30¢. In the 1950s, residents established its current site in West Friendship, where "Farm Queen" Lynn Fisher presided over the awarding of a blue ribbon to the winning steer in 1966. (Courtesy HCHS.)

RIPE FOR DEVELOPMENT. In 1960, Howard County planners predicted that the county's population would grow to 200,000 by the year 2000. Planners anticipated growth but not the purchase, several years later, of 15,000 acres by the Rouse Company and a plan to build a city. In November 1964, James Rouse presented a proposal for planned growth—the concept and design of Columbia. (Courtesy Columbia Archives.)

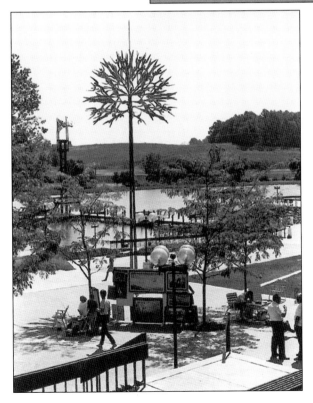

COLUMBIA ART SHOW. Opened in 1967, Columbia was designed in part to eliminate racial, religious, and income segregation. By 1970, the town center, graced by Pierre du Fayet's evocative *People Tree* sculpture, was the focal point for most town events. At this time, construction of Oakland Mills was not yet visible on the hill in the distance and US 29 was still a two-lane road. (Courtesy Donald W. Reichle.)

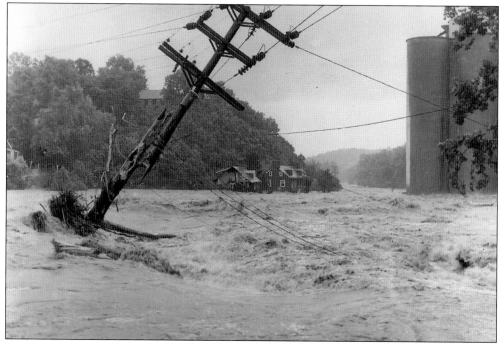

HURRICANE AGNES FLOOD, 1972. The biggest natural disaster in Howard County history roared through on June 21, 1972, when torrential rains caused the Patapsco and Patuxent Rivers to crest at record heights. Taken from upriver in Oella, this photograph shows the raging waters of the Patapsco rushing past the mill and ripping the historical, recently refurbished Jonathan Ellicott home almost in half. (Courtesy HCHS.)

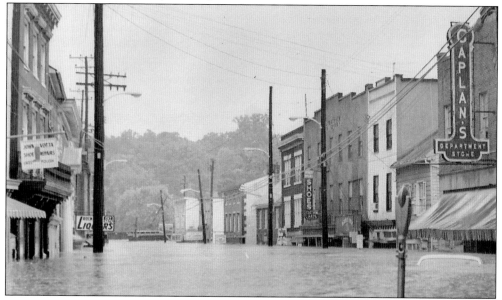

ELLICOTT CITY UNDERWATER. About to celebrate its 200th anniversary, Ellicott City was hit particularly hard by the 1972 deluge that crested at 14.5 feet above flood stage. Although not as high as the great 1868 flood's 21.5 feet, it was enough to wipe out the concrete bridge, uncover the old millrace, and submerge Main Street up to the Odd Fellow's Hall. (Courtesy HCHS.)

Two

MANORS AND MILLS

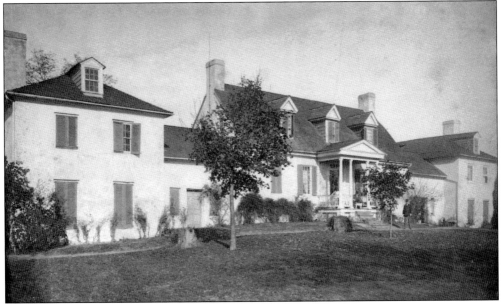

BELMONT. Located on 82 preserved acres in Elkridge and surrounded by the Patapsco State Park, Belmont is one of the oldest surviving Colonial plantations in the county. The center part of the home was built in 1738 by Caleb and Pricilla Dorsey on over 1,300 acres patented in 1695 as Moore's Morning Choice. Pictured in the late 1800s, the home remained in the Dorsey family for 229 years. (Courtesy Philip E. Stackhouse.)

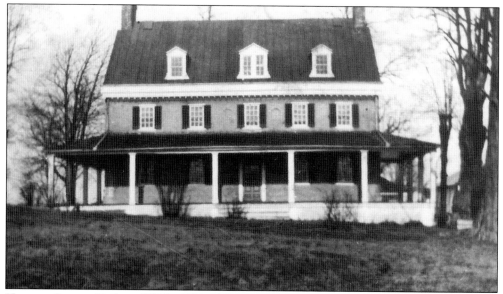

HOWARD LODGE. Built in 1750 by Edward Dorsey, Howard Lodge near Sykesville was once the home of Francis Scott Key Jr. and his wife, Elizabeth Lloyd Harwood. (Francis was the son of the famous poet). Constructed of Flemish brick bond in a transitional Federal/Greek Revival style, the home is said to be haunted by the ghost of an 18th-century-garbed man and by a small child who can be heard crying in the master bedroom. (Courtesy HCHS.)

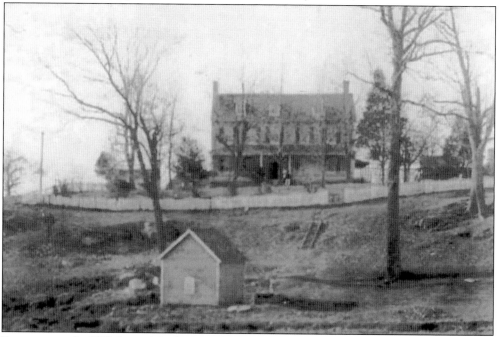

BLOOMSBERG. In 1830, James Matthews and his family moved into this stone home on 200 acres purchased from Caleb Dorsey. In 1841, Matthews was named postmaster of the town, then known as Matthews. It was renamed Glenwood in 1874 by Matthew's son Prof. Lycurgus Matthews. James and his wife, Kitty Griffith Matthews, died in the 1880s and were buried in the Oak Grove Cemetery. (Courtesy Steve Walker.)

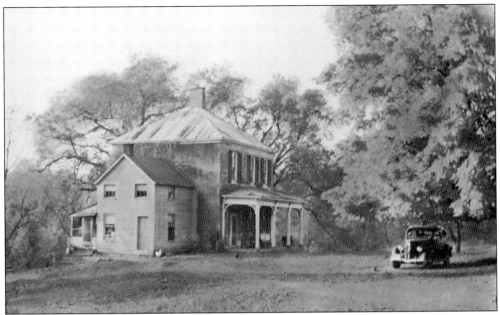

COMMODORE JOSHUA BARNEY HOUSE. Built by Charles Greenberry Ridgely Sr. around 1760 on a 700-acre tract called Harry's Lott, the house is located in what was then known as Elk Ridge. It changed hands several times before being purchased in 1809 by Revolutionary War and War of 1812 hero Commodore Joshua Barney. He retained it until his death in 1818. It is now a bed-and-breakfast in Savage. (Courtesy Savage Historical Society.)

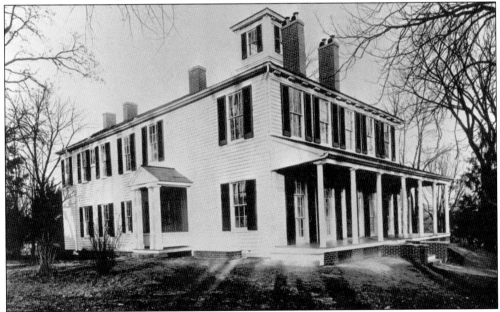

THE MANSION HOUSE. Also known as the Company House or the Proprietor's House, it was built as a summer home between the years of 1859 and 1878 by William H. Baldwin, the second owner of the Savage Manufacturing Company. Located on Washington Street in Savage, this handsome Greek Revival home was within easy walking distance of the mill. (Courtesy Savage Historical Society.)

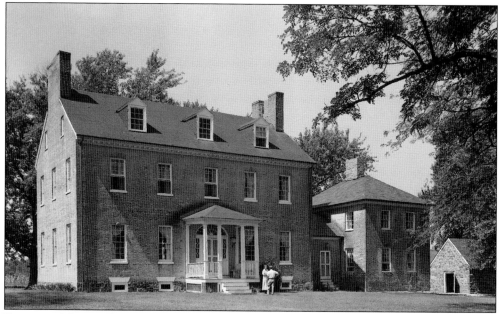

BURLEIGH MANOR. Rezin Hammond built this lovely manor around 1800. After Hammond's death in 1809, the home and 4,500 acres passed to his nephew Denton, who lived there with his wife, Sarah, until his death in 1832. Known for its exquisitely carved woodwork, sunburst fanlights, and restrained sense of style, the home, pictured here in 1936, is both an historical and architectural treasure. (Library of Congress, Historic American Buildings Survey [HABS MD, 14-ELLCI.V, 1-].)

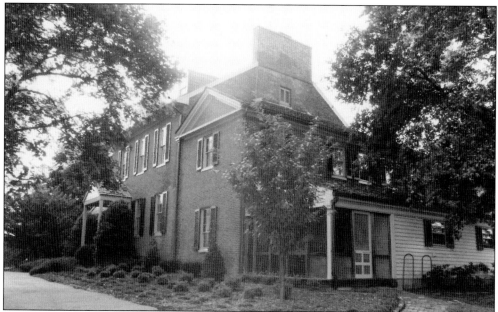

HICKORY RIDGE. Located on the northwestern edge of Highland, Hickory Ridge was built by Greenberry Ridgely on 500 acres bequeathed to him in 1749 by his father, Col. Henry Ridgely. Constructed of brick, the home features a great stair hall, fine woodwork, and two dining rooms. One was used for family meals and the other for entertaining. (Courtesy HCHS.)

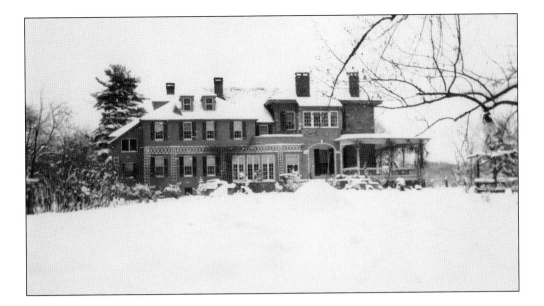

HOMEWOOD AND R.G. HARPER CARROLL II. Robert Goodloe Harper Carroll built this handsome house he named Homewood in 1872 on a portion of the family's Doughoregan Manor estate. Born in 1839, Carroll served in Company K Virginia 1st Cavalry in the Confederate army during the Civil War. Military records describe him as being five feet and seven inches tall with a fair complexion, blue eyes, and dark hair. His son R.G. Harper Carroll II is pictured here in a photograph dated 1939. Later in the 20th century, the home belonged to the Wright family, who are related to the Carrolls. Both Homewood Road and the Homewood School off Clarkesville Pike are named after this family estate. (Both, courtesy HCHS.)

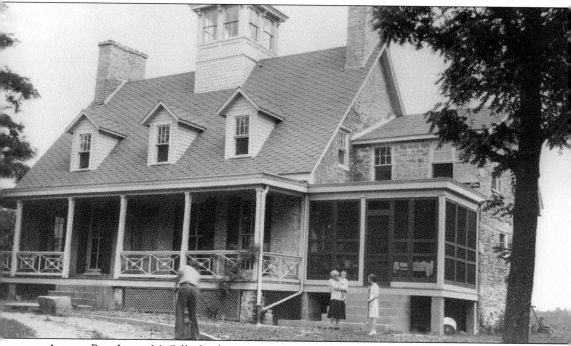

ATHOL. Rev. James McGill, the first rector of Christ Episcopal Church, brought masons from Scotland to build this "English castle" on several hundred acres patented to him in 1730. Begun in 1732, the home was not finished until 1740. Named for McGill's ancestral home in Scotland, the property is marked by a stone inscribed "Here begins Athol" that was placed and still stands at the base of a white oak tree some distance from the house. Melvin Coar owned the house from 1927 to 1946. This photograph, taken in the summer of 1929, includes Coar, his aunt Mary Coar, his one-year-old daughter Charlotte, and his sister Hilda Caroline Coar. The cupola and front porch, which were likely 19th-century additions, have since been removed. (Courtesy HCHS.)

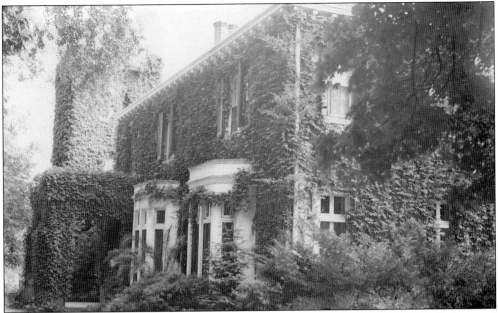

GLENELG MANOR. Operated as the Glenelg Country School since 1954, this exceptionally fine rural Gothic Revival mansion was built on land that was originally part of Dorsey's Grove, which was patented in 1721. Initially known as Howard's Resolution, the original stone home was purchased by Gen. Joseph Tyson in 1845. Tyson added the Norman Tudor facade and crenellated tower, modeling it after the Glenelg Castle he had seen in Scotland. (Courtesy HCHS.)

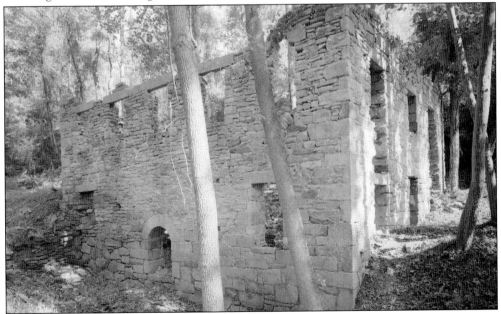

SIMPSONVILLE MILL. Standing on land patented by John Martin in 1719, this mill (or an earlier one) was referenced on a deed dated 1789. Used for a variety of purposes, including as a woolen factory, gristmill, and sawmill, the structure and surrounding property were purchased by the Simpson family in 1852. Today, only a few stone ruins remain. (Library of Congress Historic American Engineering Record [HAER MD, 14-COLUM.V, 1-].)

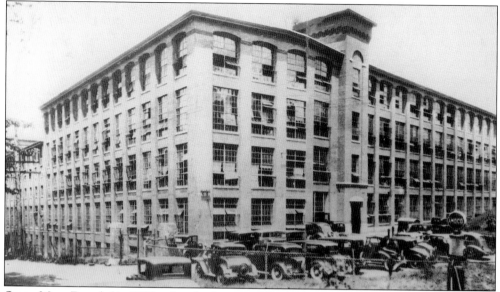

OELLA MILL. Founded in 1808 and said to be named for the first woman to spin cotton in America, the Union Manufacturing Company's Oella Mill was briefly known as the largest cotton mill in America. Located across the Patapsco from Ellicott's Mills, the property was bought at auction by William J. Dickey in 1887. The mill burned in 1918 but was rebuilt, as seen in this 1920s image, claiming fame as a producer of woolens. (Courtesy Charles L. Wagandt.)

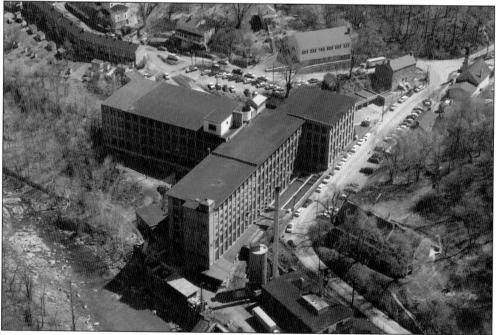

MILL TOWN, 1960s. The first stone mill workers' homes along Oella Avenue were built shortly before the War of 1812. These homes, as well as log cabins, pre–Civil War brick homes, Victorian frame houses, and World War I–era cottages, created an eclectic village that remained even after the mill closed in 1972. The town and mill survive and thrive today due to the stewardship of William J. Dickey's grandson Charles Wagandt. (Courtesy Charles L. Wagandt.)

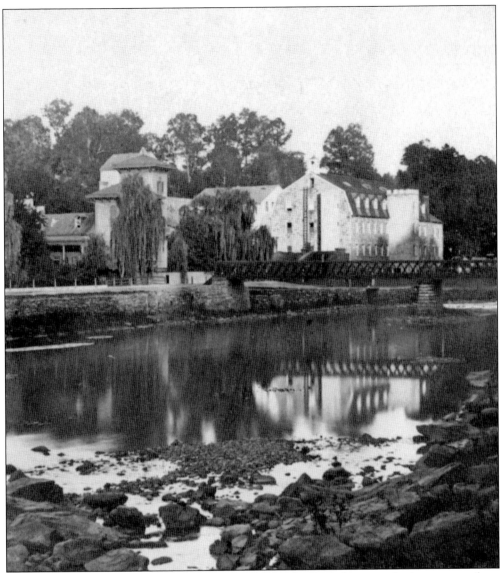

GRAY'S PATAPSCO FACTORY. Records from 1779 show this site, about a mile downstream from Ellicott's Mills, to be the home of the Godfrey and Ellicott Distillery. Thomas Mendenhall bought the site in 1794 and built a paper mill there, which operated through 1812. In 1813, the Patapsco Manufacturing Company bought the mill and began producing cotton yarn. In 1844, Edward Gray purchased the mill and added the production of woolen fabric. This mid-19th century view is of a greatly improved site, complete with an elegant Italianate tower added by noted novelist and congressman John Pendleton Kennedy when he used one of the buildings as a summer home in the 1860s. Although the mill was severely damaged in the 1868 flood, it remained in business until 1888. (Courtesy Maryland Historical Society.)

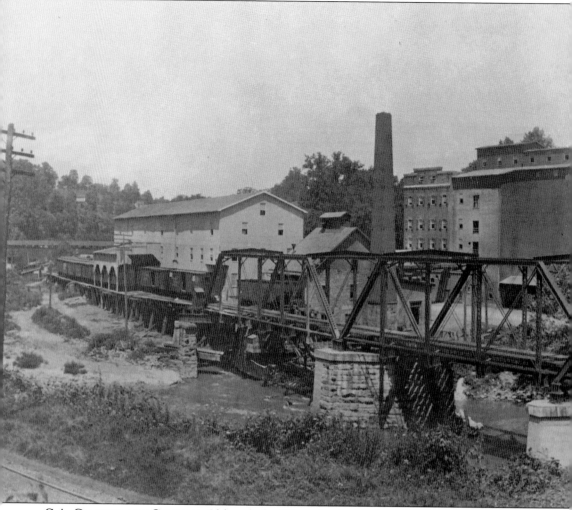

C.A. Gambrill and Company. Although the Ellicott brothers' original 1774 mill burned in 1809, the family stayed in the milling business until 1844, when a partnership between Charles Carroll and Charles A. Gambrill took over. The partnership continued until Carroll died in 1863 and Gambrills began renting the mills and operated them under his own account. The Carroll estate owned the mill until the 1868 flood, when they sold the partially destroyed operation outright to

Charles Gambrill and his nephews. The Gambrill family rebuilt the mills and greatly expanded operations. By 1900, mills stood on both sides of the millrace and Frederick Road. This view from the Ellicott City side of the river includes the B&O Railroad spur leading into the loading bay. A full 48 years after being rebuilt, the mills burned down in 1916. (Courtesy HCHS.)

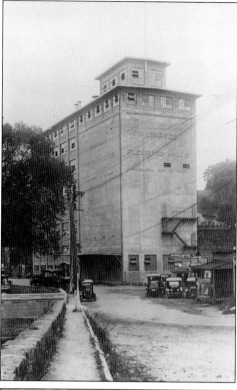

PATAPSCO FLOURING MILLS. After the Gambrill mill burned in 1916, a new mill was built on the same site in 1918. Sometime after World War I, the Doughnut Corporation of America purchased it. In 1940, it was the company's largest factory, employing 2,000 workers and running 20 hours a day. Wilkins-Rogers bought the plant in 1967 and continues to make Washington Flour and Indian Head Cornmeal here today. (Courtesy HCHS.)

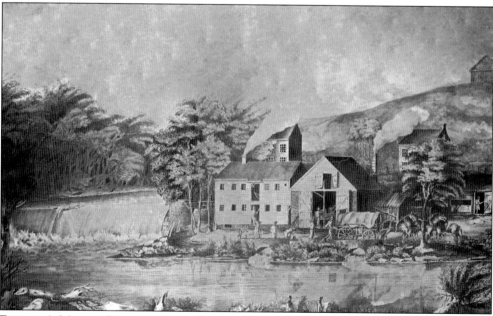

ELLICOTT'S MILL AT PATAPSCO FALLS. In 1822, Ellicott brothers Benjamin, James, and Thomas established Ellicott's Slitting Mill and Nail Factory upstream from Elkridge in Avalon on the old site of Dorsey's Forge. A fire in 1845 destroyed the nail factory, and the floods of 1866 and 1868 demolished the rest. In 1910, Victor Blode bought the site to build a water filtration facility, which was destroyed in the 1972 flood. (Courtesy HCHS.)

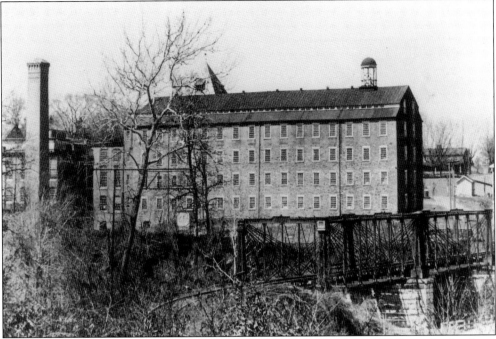

SAVAGE MANUFACTURING COMPANY. Chartered in 1822 by Amos Adams Williams, his brothers, several associates, and John Savage, the cotton mill and factory company made sails for tall ships, among other cotton duck products. Built on a tract called White's Contrivance at the falls of the Patuxent River, the mill welcomed a spur of the B&O Railroad in 1887, along with the installation of the Bollman Truss Bridge. (Courtesy HCHS.)

FROM COTTON TO CHRISTMAS ORNAMENTS. In 1859, William Baldwin purchased the Savage Manufacturing Company, and it remained in the hands of the Baldwin family until the 1940s. In 1948, Harry H. Heim bought the mill to produce Christmas ornaments and to create the short-lived Christmas village of Santa Heim, Merrieland. (Courtesy Savage Historical Society.)

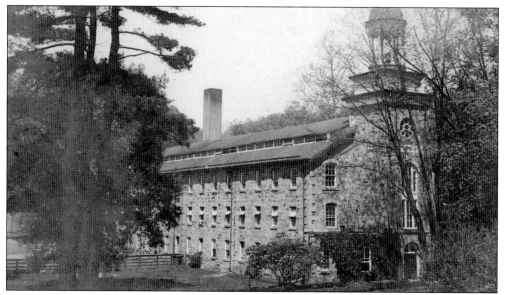

ALBERTON MILL AND DANIELS. Located about five miles upriver from the original Ellicott's Lower Mills, in what was known in the 1830s and 1840s as Elysville, the first mill in operation at this site was the O'Kisco flour mill. In the 1850s, James S. Gary bought the property and began milling cotton at what was called the Alberton Mills at Elysville. In 1940, the entire 500-acre town was sold to the C.R. Daniels Company for $65,000, including the mill, the churches, and 118 houses. Because of financial concerns, the mill owners decided to phase out housing for employees in 1965. The homes were subsequently torn down. In 1972, the Hurricane Agnes flood swept away the mills and remaining buildings. The ruins of Daniels Mill were added to the National Register of Historic Places in 1979. (Both, courtesy HCHS.)

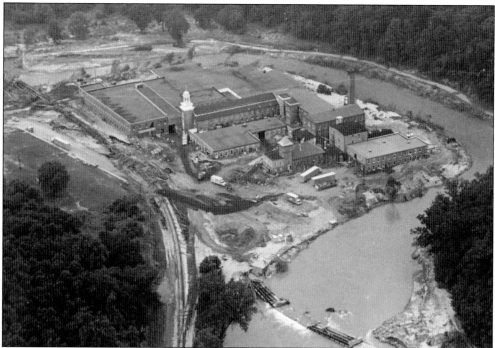

Three

TOWNS

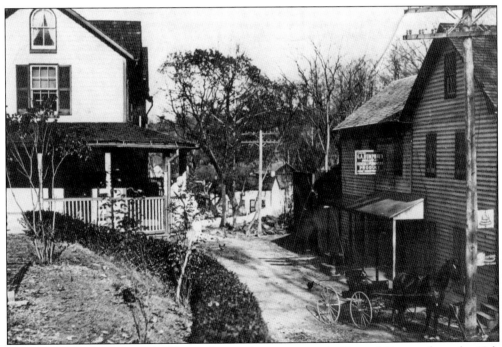

WOODSTOCK, C. 1900. While Ellicott City took center stage in Howard County from the 18th century until the late 20th century when Columbia made its name, many other towns and close-knit communities dotted the countryside. Here, near the border of Carroll and Baltimore Counties, is a view of the town of Woodstock and G.A. Humphry's General Store. (Courtesy HCHS.)

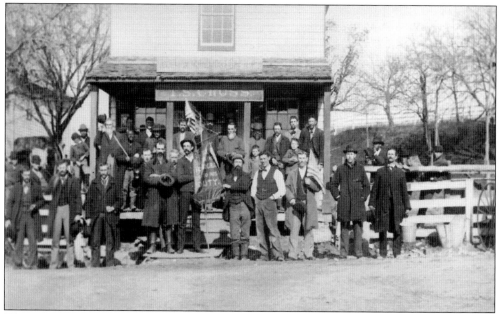

WEST FRIENDSHIP, C. 1890s. Neighbors gather at Thomas S. Cross's store in West Friendship for what appears to be a political rally or patriotic celebration. Joshua Hamilton Cross, born in 1874 as the son of Thomas and Emma, appears in the front row in a vest and his shirtsleeves. The Cross family sold this store around 1900. (Courtesy HCHS.)

CALEB PANCOAST HOUSE, LISBON. Laid out during the beginning of the 19th century, Lisbon stands on land that was once part of Warfield's Forest, patented to Seth Warfield in 1794. Originally known as New Lisbon, the name was shortened after Caleb Pancoast built his home (between 1804 and 1805) and opened it as a central meeting place for all faiths. (Courtesy the Celia Holland Papers, Special Collections, University of Maryland Libraries.)

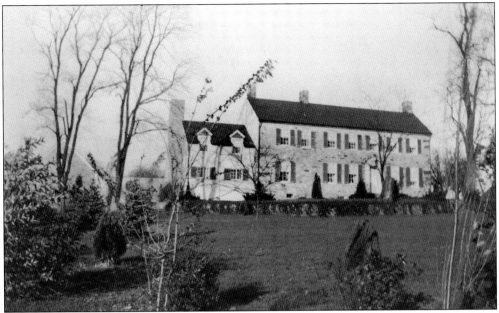

MERIWEATHER, GLENELG. Although this home is said to have been built by Henry Meriweather in 1805 when the land was part of Anne Arundel County, the property's first recorded Howard County deed is dated September 15, 1865. It appears on the Martinet map of 1860 as the home of Samuel T. and Elizabeth A. Owings. In recent times, it is best known as the site of the Howard County Hunt Club race. (Courtesy HCHS.)

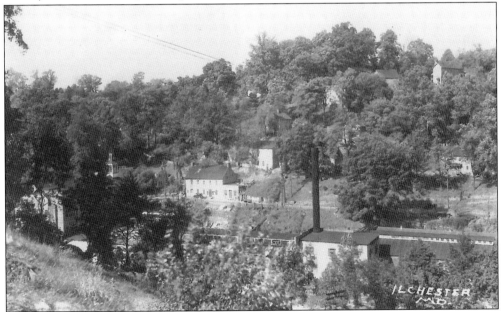

ILCHESTER. Located downstream from Ellicott City, this town was founded in the 1830s by George Ellicott, who had grand plans for creating a thriving stopping place along the newly opened B&O Railroad line to Baltimore. Unfortunately, because the hilly terrain made stopping at Ilchester unwise, the trains passed by Ilchester. Local mills and a seminary sustained the village for a while, but it crumbled into ruins in the late 1900s. (Courtesy HCHS.)

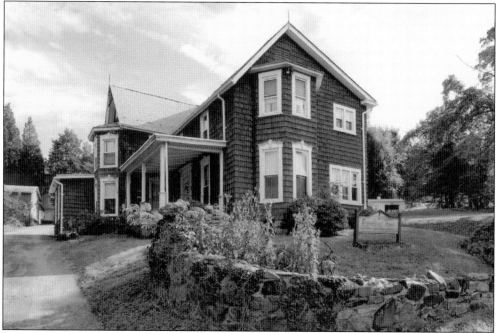

ELKRIDGE. The oldest settlement in Howard County, Elkridge was originally called Jansen Town and later Elk Ridge Landing. It was an important port for shipping tobacco and iron to England. The home of a number of doctors and their families, this c. 1877 Elkridge home on Main Street was purchased by Dr. Brumbaugh in 1921. He would treat three generations of residents until his death in 1985. (Courtesy Donald W. Reichle.)

ANDREWS HOUSE, C. 1920S. In 1912, the Patapsco Forest Preserve was created to reforest the areas that had been depleted by the Patapsco Valley mills. In 1917, the Andrews family came to Elkridge from Locust Point in Baltimore to escape the summer heat. They fell in love with the area and purchased a home on Augustine Avenue in 1921. The Andrews brothers opened the Elkridge Trailer Park in 1939. (Courtesy Suzanne Grabowski Bergren.)

ELIBANK'S COTTAGE. Located in Elkridge on a tract that was originally part of Rockburn and later known as Tutbury, this charming house started out as a small cottage when it was purchased by Samuel and Mary Hoogewerff in 1854. Five generations of Hoogewerffs used it, mostly as a summer home, until it was sold out of the family in 1966. (Courtesy HCHS.)

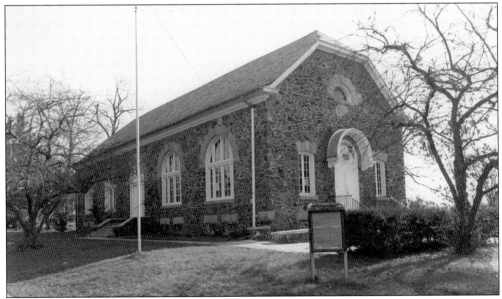

CARROLL BALDWIN MEMORIAL HALL, SAVAGE. Built in 1921 to honor the president of the Savage Manufacturing Company who served from 1905 to 1918, this eclectic community hall blends a Richardsonian Romanesque style with elements of Beaux-Arts and Queen Anne styles. The focal point of a wide range of community activities over the years, it once housed the Savage branch of the Howard County Library. (Courtesy Savage Historical Society.)

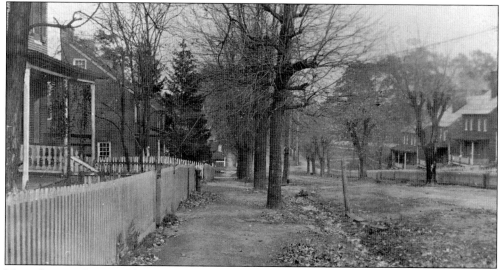

MAIN STREET, SAVAGE. This view looking east down Baltimore Street includes mill homes with tidy front porches and picket fences. The houses were removed by Harry Heim when he purchased the Savage Manufacturing Company in 1948. (Courtesy Savage Historical Society.)

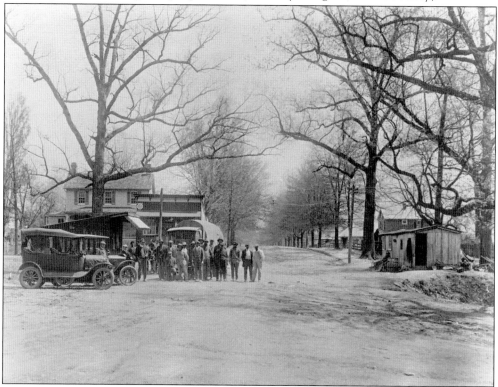

WASHINGTON STREET, SAVAGE. In this c. 1920s photograph, men gather at a contractor's plant on one of the principal streets in the town of Savage. These Savage Manufacturing Company workers wove canvas, which early on was used in making sails for clipper ships and later for painted backdrops in silent movies and as canvas products for US soldiers during both World Wars I and II. (Courtesy Savage Historical Society.)

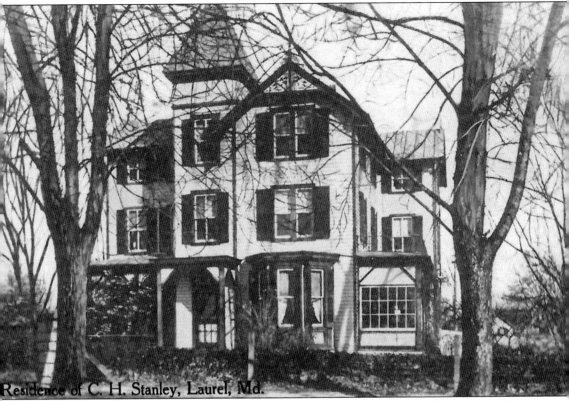
Residence of C. H. Stanley, Laurel, Md.

HOME OF CHARLES H. STANLEY, LAUREL. Known as Laurel Factory in the 18th and early 19th centuries, the town of Laurel is located along the Patuxent River in both Howard and Prince Georges Counties. A variety of mills, most notably the Patuxent Manufacturing Company built in 1835, served as the town's primary economic engine through the 1940s. Incorporated as a town in 1870, Laurel elected Charles H. Stanley mayor in 1891. A man of many interests, talents, and accomplishments, Stanley was founder and president of Citizen's National Bank of Laurel, director of the B&O Railroad, a founding member of the board of trustees for the University of Maryland, a member of the Maryland House of Delegates, and the comptroller of Maryland. He lived in this home with his wife, Margaret Snowden, and their nine children. (Courtesy HCHS.)

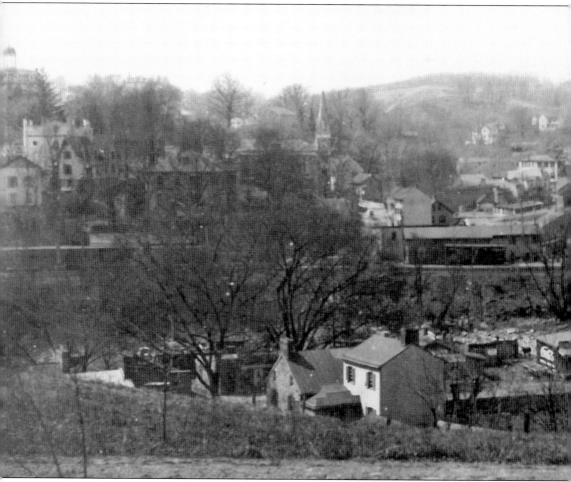

ELLICOTT CITY. In 1772, three Quaker brothers from Bucks County, Pennsylvania—John, Andrew, and Joseph Ellicott—first established a flour mill on the Oella side of the Patapsco River. In the process, they founded the town of Ellicott's Mills. Powered by the engine of industry and the fast flowing river, the town prospered. In 1830, it became home to the first terminus of the B&O Railroad, and in 1851, when the county became an independent jurisdiction, it was the seat of

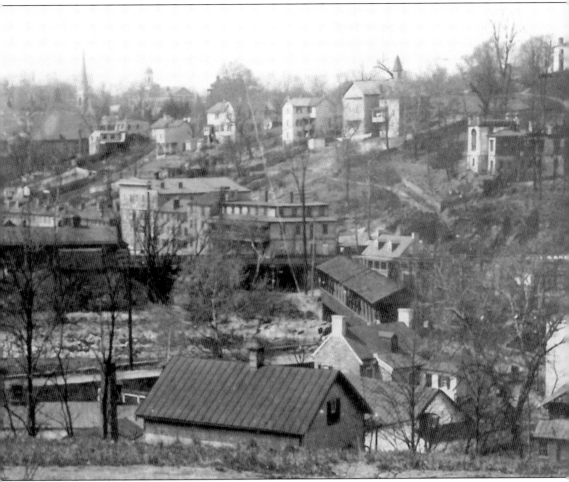

county government. The name was changed to Ellicott City when the town was chartered in 1867. Repeatedly devastated by catastrophic floods, frequent fires, and economic downturns that threatened its very existence, Ellicott City survives today as a cultural, architectural, and historical treasure. This photograph of the town, taken from a hill in Oella around 1900, includes a wide range of landmarks. (Courtesy HCHS.)

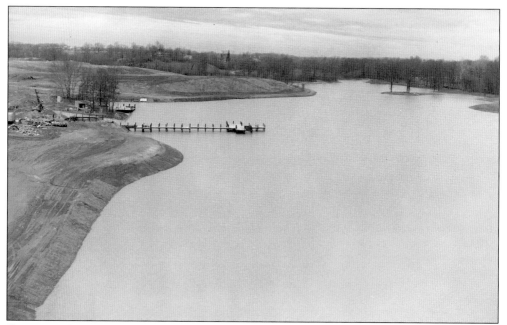

COLUMBIA, LAKE KITTAMAQUNDI, 1966. The Rouse Company named the man-made lake in Columbia's Town Center to convey its purpose—serving as a gathering place. Kittamaqundi is a Native American word meaning "friendly meeting place." Columbia's first office buildings were constructed along the lakefront, creating the core of the Town Center design that is in scale with nature. (Courtesy Columbia Archives.)

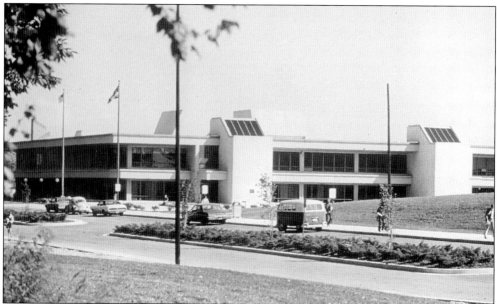

HOWARD COMMUNITY COLLEGE. Opened in 1970 in Columbia's Town Center, the campus was surrounded by farmland and consisted of one building that housed classrooms, offices, the library, and the cafeteria. The first class totaled about 600 part-time and full-time students and 10 full-time faculty. The college, like Columbia itself, was a promise of things to come and an important part of the transformation of Howard County. (Courtesy Columbia Archives.)

Four

CHURCHES AND SCHOOLS

FIRST PRESBYTERIAN CHURCH, ELLICOTT CITY. Erected in 1894, just eight months after the original church on the site collapsed, the building features a 100-foot steeple and a cherub-themed rose window that depicts Henry and Melissa, the children of Rev. Henry Branch. The children died in infancy. In 1960, Alda Hopkins Clark purchased the building and donated it to the HCHS in memory of her late husband. (Courtesy H. Branch Warfield.)

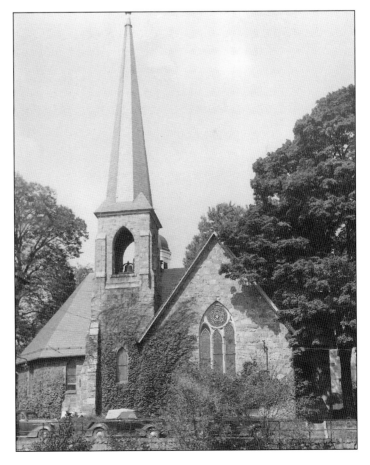

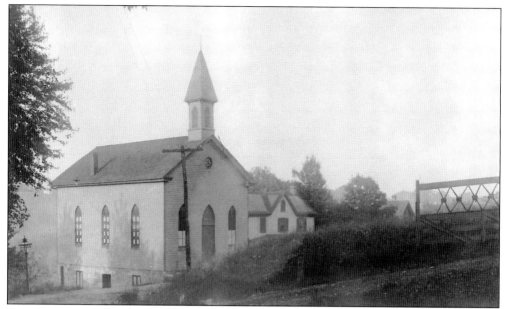

FIRST EVANGELICAL LUTHERAN CHURCH, ELLICOTT CITY. Perched on a hillside overlooking Ellicott City and the Patapsco River, this two-story Carpenter Gothic church was built in 1874 by German immigrants who had been traveling to Catonsville to worship for the previous 26 years. In 1956, because of an expanding congregation, the church moved out to a site donated by Charles Miller on Chatham Road. Today, the church is a private home. (Courtesy HCHS.)

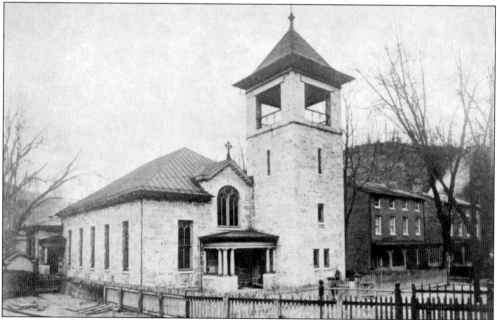

ST. ALBAN'S CHAPEL, DANIELS. Part of the Alberton mill town complex, St. Albans was an Episcopal church that served the town's congregants between the years of 1893 and 1918. In the 1897 Diocese of Maryland journal of the 112th annual convention, the recently ordained Rev. Cornelius S. Abbott Jr., missionary, was listed as the parish clergyman. (Courtesy Baltimore County Public Library Legacy Web.)

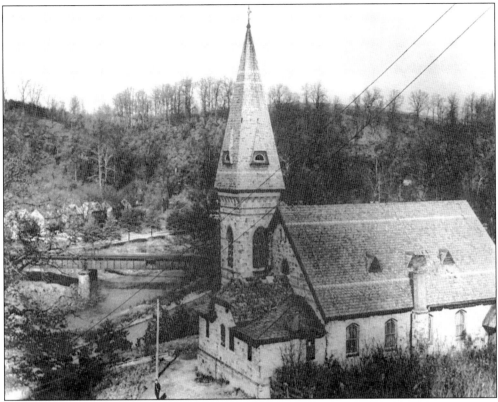

GARY MEMORIAL CHURCH, DANIELS. This church was built by James Albert Gary to honor the memory of his father, James S. Gary, who bought the mill and town in the 1860s. Constructed of local granite in 1879 and 1880 on Standfast Hill overlooking the Patapsco River and the ruins of Daniels, today this High Victorian Gothic house of worship is part of the United Methodist Church. (Courtesy Philip E. Stackhouse.)

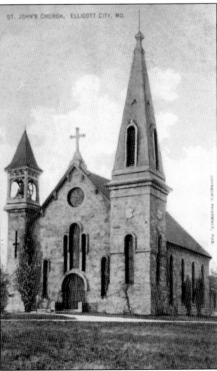

ST. JOHN'S EPISCOPAL CHURCH, ELLICOTT CITY. Founded in 1822, the original Greek Revival stone church was built in 1825 on land deeded by Caleb Dorsey and his wife, Elizabeth. In 1859, noted architect N.G. Starkwether drew up plans for a new Gothic-style church to be built on the site that would include a spectacular 83-foot solid stone spire and wooden arched belfry. (Courtesy HCHS.)

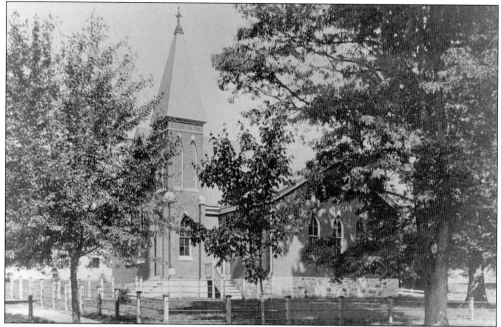

THE SAVAGE METHODIST EPISCOPAL CHURCH NORTH. Between the early 1800s and the time this church was built, Methodist circuit ministers traveling by foot or horseback would visit Savage once a month. In 1888, William Henry Baldwin, owner of the Savage Manufacturing Company, gave the land, built, and furnished "the brick church," located at 9050 Baltimore Street. (Courtesy Savage Historical Society.)

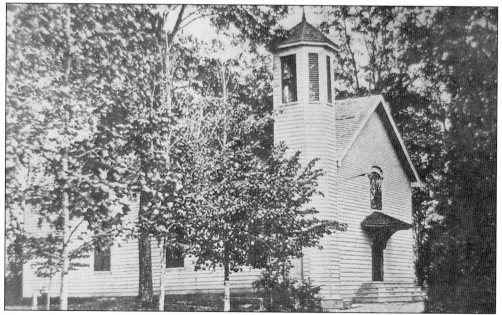

TRINITY EPISCOPAL CHURCH, ELKRIDGE. Built in Elkridge on land donated by Dr. Lennox Birckhead and William G. Ridgely, Trinity Chapel, also known as Trinity on the Pike, was started on July 30, 1856, and completed as a plain board building in early 1857. Later that year, a Sunday school building was erected, and in 1867, the bell tower and sacristy were added. (Courtesy HCHS.)

METHODIST EPISCOPAL CHURCH, LAUREL. In 1842, the Laurel Mill Company presented a "gift of stone and a grant of land" to the town's Methodists for the first house of worship in Laurel. In 1884, the congregation moved from the old stone church and built this brick church, naming it Centenary M.E. Church in commemoration of the 100th anniversary of the founding of Methodism in America. (Courtesy HCHS.)

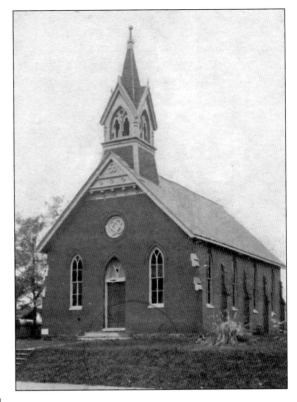

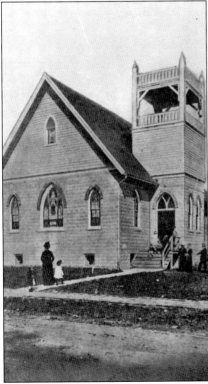

SOUTHERN METHODIST CHURCH, LAUREL. Laurel Methodists split when slavery became an issue during the Civil War. Those who sided with the Confederacy's position started the Methodist Episcopal Church, South. In 1866, the Southern Methodists in Laurel built their own church, known as the "frame church" to distinguish it from the old stone church. In 1912, they moved into a new church, which was known as Trinity M.E. Church, South. (Courtesy HCHS.)

OLD MOUNT PISGAH AME CHURCH, COLUMBIA. Founded in 1898 by William Richardson, the church's first congregation began meeting in a log cabin owned by George Jones in the African American community of Jonestown. In 1901, Bellows Spring Methodist Church donated a building that was moved to the site. That building burned and was replaced by the church in this 1923 photograph. (Courtesy HCHS.)

WEST LIBERTY UNITED METHODIST CHURCH. The congregation, which is believed to have been founded in 1851 in an area that was known as Woodford, met in a building that served as a school during the week. In 1869, it became a part of the Methodist Episcopal Church. The current structure was built in 1885. In 1911, the trustees bought the land in what is now known as Marriottsville from George and Matilda Ridgely for $82.50. (Courtesy HCHS.)

St. Barnabas Episcopal, Sykesville. Because the three-mile trip from Sykesville to Eldersburg was too long for the less privileged mill workers' families to make, Susanna Warfield petitioned for a new chapel of ease in Sykesville in 1844. The cornerstone was laid on June 11, 1850, on the Feast of St. Barnabas, and the church was consecrated on December 11, 1851. The original pews, altar, windows, woodwork, and hardware remain today. (Courtesy HCHS.)

Daisy United Methodist Church. The church was established in 1876 when Dennis and Leanna Gaither gave 2.25 acres for the purpose of erecting a school and a "house of public worship for the use of the colored members of the M.E. Church of the neighborhood." Hanson Dorsey was the first to preach in the new log building, which was replaced in 1906 by the one that stands in Daisy today. (Courtesy HCHS.)

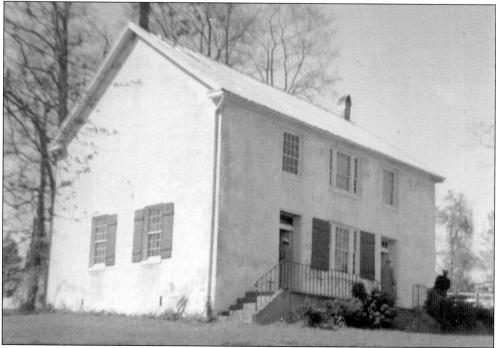

Union Chapel, Glenwood. Completed in 1833, this simple stuccoed stone church in Glenwood was constructed at a total cost of $1,459 on land deeded to the church by Charles D. Warfield. In 1886, the chapel was part of the Lisbon circuit of the Methodist church, along with Jennings Chapel and Poplar Springs. (Courtesy HCHS.)

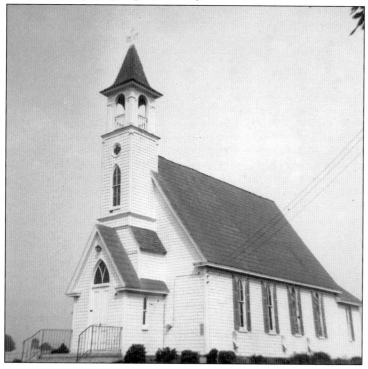

St. Paul's Episcopal Church, Poplar Springs. The first chapel of ease in Poplar Springs was constructed in 1753, about two miles from where the current church stands today. Built in 1883 on a half acre of land originally known as the Additional Defense and deeded to the church by Elias Green Selby and America M. Selby, this Carpenter Gothic–style building was erected at a cost of $1,500, which included the bell tower. (Courtesy HCHS.)

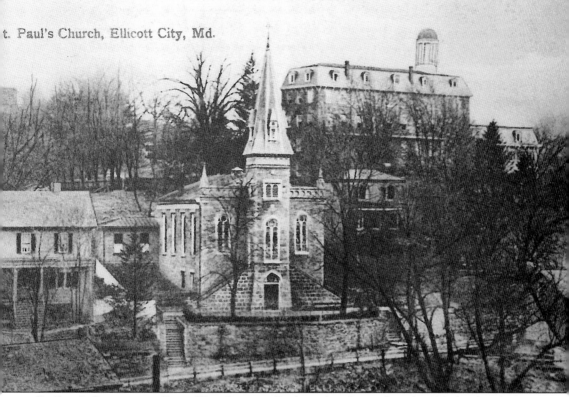

St. Paul's Church, Ellicott City, Md.

ST. PAUL'S CHURCH AND ROCK HILL COLLEGE. Dedicated on September 13, 1838, the church was built on land acquired from George Ellicott. At the time, the inside was plain and unpainted and there were large glass windows. During the Civil War, the basement was used as a hospital for both Northern and Southern soldiers. A series of renovations begun after the war added frescoed walls, a marble altar, and elaborate German silver chandeliers. In 1896, the steeple, topped with a Celtic cross, was added. Rock Hill Academy, later elevated to a college, was located above St. Paul's Church. Isaac Sams founded the school in 1822, and in 1824, he had the massive stone structure designed and built by Baltimore architect George A. Frederick. Billed as a "select boarding school for young men and boys," the school offered "literary, scientific, commercial, and preparatory" courses until it burned down in 1923. (Courtesy HCHS.)

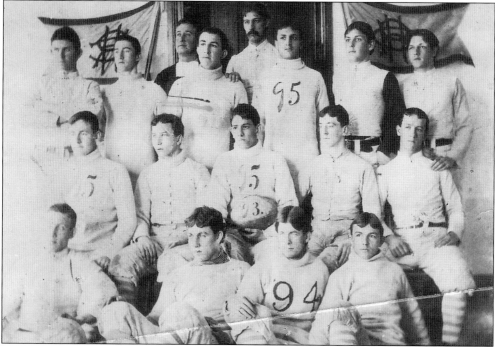

ROCK HILL COLLEGE FOOTBALL TEAM. Between 1894 and 1922, the college fielded a football team that played on a large recreation field known as Forty Acres on New Cut Road. The team, from left to right, included: (first row) Echonrode, Sullivan, Dickey, and Langhorn; (second row) Towhey, Walker, James, O'Donoghoe, and Martin; (third row) Whooley, Kelley, O'Brien, Autand, Coleman, and Alvarez; (fourth row) Brother Joseph and Professor Egerton. (Courtesy HCHS.)

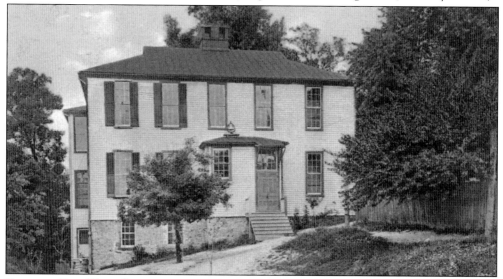

ELLICOTT CITY HIGH SCHOOL, C. 1919. In 1820, boys in Ellicott City were taught in a stone schoolhouse, now known as the Weir building on Court Avenue. The school was moved to this location, on what was then known as Strawberry Lane, in 1824. It served as the town's coed high school until the school was moved once again, this time to a new facility on College Avenue. This structure, near the courthouse, was demolished in 1925. (Courtesy HCHS.)

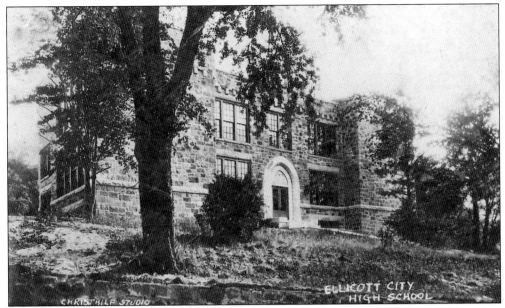

ELLICOTT CITY HIGH SCHOOL, C. 1924. Designed by Pietsch and Emory architects, this building was constructed in 1924 on the site of the burned Rock Hill College, possibly using some of the stone. This school replaced the old frame high school near the courthouse, and despite its name, it housed grades one through 11. In the 1930s, the high school moved again. The building continued to serve as an elementary school, which closed in the 1970s. (Courtesy HCHS.)

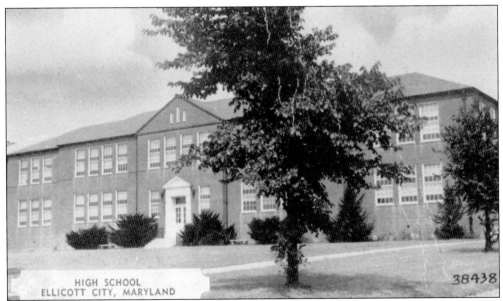

ELLICOTT CITY HIGH SCHOOL, C. 1939. Senior high school students moved again in 1939, this time to a school located on Montgomery Road. During the 1940s, it was a hub of community activity, even hosting the Howard County Fair in 1947. Later, more high schools opened around the county, and this became a middle school. In 1999, the structure was demolished to make way for a modernized Ellicott's Mills Middle School. (Courtesy HCHS.)

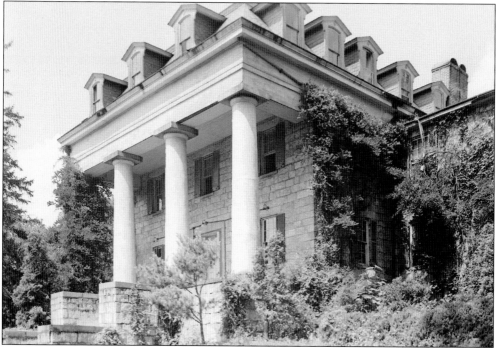

THE PATAPSCO FEMALE INSTITUTE, C. 1936. Established in 1837 as a school for girls aged 12 to 18, it prospered in the mid-19th century once Almira Phelps became principal. Enrollment soared to 300 thanks to a challenging curriculum that included botany, geology, religion, and the classics. In 1838, young women from wealthy families as far away as Texas paid $100 in tuition and board for each five-month session. (Courtesy Library of Congress Historic American Engineering Record, [HABS MD, 14-ELLCI, 2-1].)

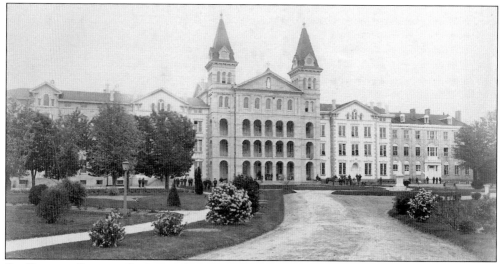

ST. CHARLES COLLEGE. Built in 1831 on 253 acres donated by Charles Carroll of Doughoregan Manor, this Society of St. Sulpice seminary school did not officially open until 1848. Between that time and 1898, a full 900 students were ordained into the priesthood. In 1911, a fire destroyed the sprawling 367-foot-long structure, which had boasted 15.5-foot ceilings, gas lighting, and radiant heat. (Courtesy HCHS.)

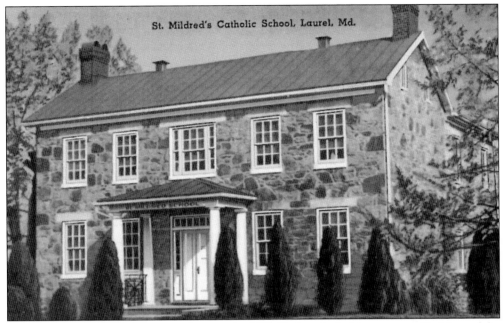

St. Mildred's Catholic School, Laurel, Md.

ST. MILDRED'S CATHOLIC SCHOOL, LAUREL. In 1913, Fr. Joseph A. Myer came to St. Mary of the Mills parish in Laurel and started a parochial school for the children. Named after his own sister, Sr. M. Mildred, the first school was housed in a Colonial mansion known as the Tiffany Estate, which had belonged to the manager of the Laurel Mills. (Courtesy HCHS.)

SCHOOL DAYS, C. 1910. Ellicott City schoolteachers Mamie Scott, Annie Johnson, Elmer Harn, and Myra Hobbs were in charge of teaching the town's children everything from their ABCs to classical history. Around this time, 60-year-old Annie Johnson lived near the school at Amy E.E. Mercier's boardinghouse on Court Avenue. (Courtesy HCHS.)

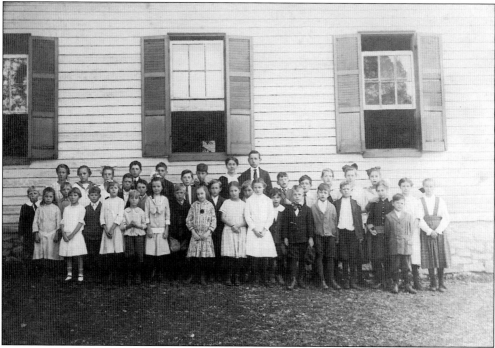

GUILFORD SCHOOL, 1910. The town of Guilford on the banks of the Patuxent was a bustling center for milling, quarrying, and cloth production from the late 18th century to the early 20th century. The old Guilford School, pictured, was built in 1876 and remained in operation until 1941. Afterwards, the school, located on the northwest corner of Guilford Road and Oakland Mills Road, was used as a home and then torn down. (Courtesy HCHS.)

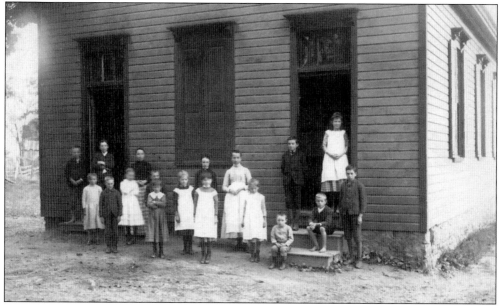

VIRGINIA HARDY'S SCHOOL, HIGHLAND. Located in Highland, the school was run by Virginia Hardy, who was listed as a 57-year-old single head of household schoolteacher in the 1900 federal census and the principal of a boarding school in 1910. (Courtesy HCHS.)

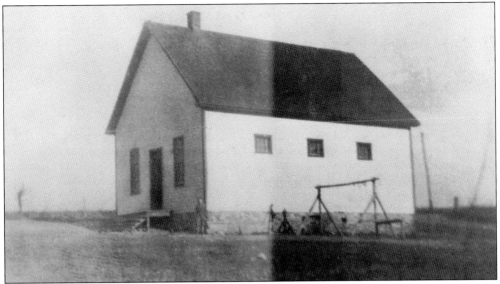

ANNAPOLIS ROCK SCHOOL, LISBON. This one-room schoolhouse with a potbellied stove was the place of veteran Howard County schoolteacher Elaine Lynn's first teaching assignment in 1934. She taught all seven grades, earning $90 a month, $25 of which she paid to a local family for room and board. If the weather was good, she would hike with her students to Annapolis Rock to have a picnic lunch. (Courtesy HCHS.)

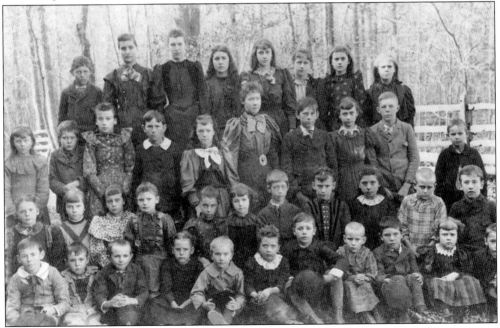

NUMBER EIGHT SCHOOL, 1895. Located off Route 32, the class picture from this one-room schoolhouse includes four children of Joshua Dorsey Warfield Sr. (an early county commissioner) and Elizabeth Causey Polk of Solopha. In this image are Lee Owings Warfield Sr. (third row, fourth from left), Charles Alexander Warfield (third row, seventh from left), Elizabeth Polk Warfield (second row, second from left), and William Causey Warfield (first row, first from left.) (Courtesy Lee Owings Warfield III.)

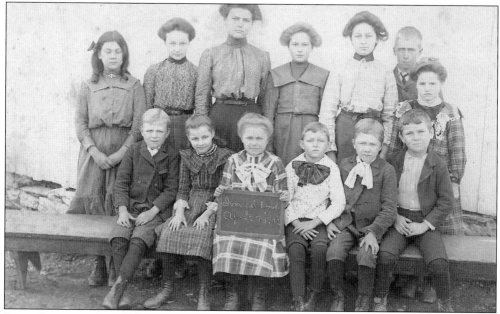

IVORY SCHOOL, 1902. Taken on April 7, 1902, outside the schoolhouse, this photograph is of the students of the Ivory School. Included in this image are, from left to right, (first row) Earnest Sheppard, Bessie Sheppard, Lilian Sheppard, Walter Sheppard, Elmer Sheppard, and Harry Selby; (second row) Adelaide Selby, Rachael Eyre, Louie Lacey (teacher), Carrie Sheppard, Annie Penn, Clayton Saumenig, and unidentified. (Courtesy HCHS.)

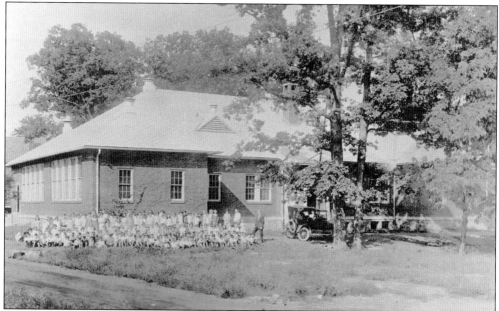

SAVAGE SCHOOL. Built in 1921 and located next to the commons near Baldwin Hall, this school had a very short life. Because it was built on a landfill, the ground settled under the weight of the structure and the walls began to crack. The school was condemned in 1937, and classes were forced to meet in neighboring buildings until a new school could be constructed. (Courtesy Savage Historical Society.)

WEST FRIENDSHIP SCHOOL. To build the West Friendship Consolidated High School in 1925, local farmers excavated the original site with horse-drawn scoops. Built to bring students in grades one through nine from one-room schoolhouses together under one roof, the school had a total of 100 students that first year. Students walked, were driven, or paid $2 per school year to ride in open-sided vegetable trucks called "huckster buses" to school. (Courtesy H. Branch Warfield.)

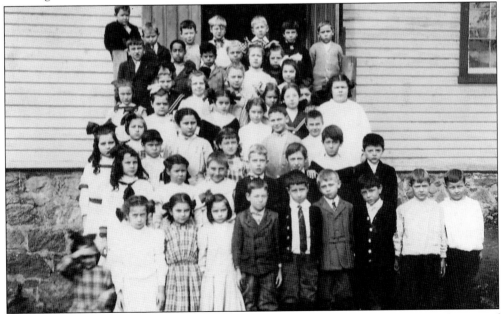

ELLICOTT CITY SCHOOL, 1911. This rather large class of second-graders includes a wide range of children from well-known Ellicott City families. Among them is Walter Kraft, pictured in the first row, fourth from the right. Others include Lee Rosenstock, Harrison Yates, Lionel Burgess, Lea Radcliffe, Joe Malone, and Rinaldo Dorsey, who made his way to school from his family's home on College Avenue. (Courtesy HCHS.)

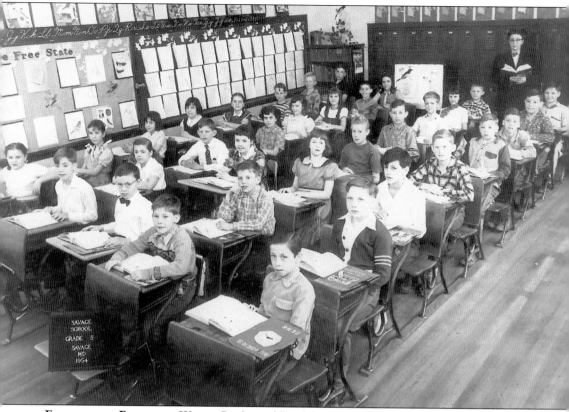

EDUCATION IN BLACK AND WHITE. By the middle of the 20th century, Howard County classrooms were swelling with baby boom generation students. Here, the 32-member fifth-grade class of the Savage School pauses with their books open to have their class picture taken in 1954. At this time, schools were still segregated. Minutes of the August 16, 1955, meeting of the Howard County Board of Education acknowledged the Supreme Court decision regarding the unconstitutionality of segregation, saying, "A prompt and reasonable start has been made toward the elimination of racial discrimination in public schools of Howard County." However, the "colored" schools continued to operate in Ellicott City, Dayton, Highland, Meadowridge, and Elkridge. School segregation in Howard County did not officially end until 1965, because a policy of voluntary desegregation resulted in only a fraction of black students attending white schools. (Courtesy HCHS.)

Five

COMMERCE

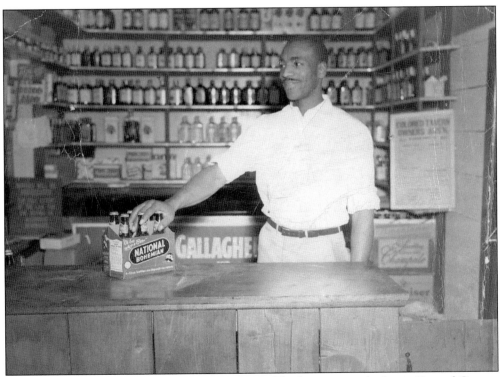

EDGAR BARKSDALE, FIRST BLACK TAVERN OWNER. The first person of color in Howard County to own his own liquor license in the 1940s, Barksdale ran a tavern and later what was regarded as the best-stocked general grocery store along the Baltimore-Washington Boulevard. His other entrepreneurial ventures included vending machines, sanitation services, and apartment rentals that helped support his wife, Clarice Charity Barksdale, and their nine children. (Courtesy Barksdale family collection.)

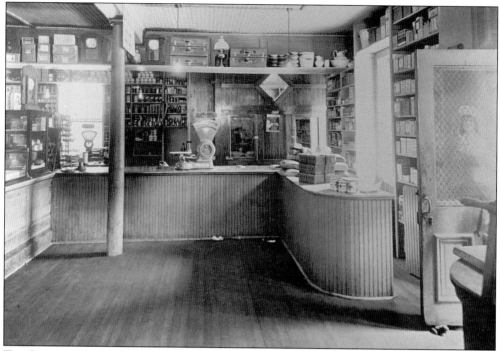

THE COMPANY STORE, SAVAGE. The Savage Manufacturing Company maintained a company store on what is now Commercial Street. Workers were issued script in the denominations of 25¢, 50¢, $1, and $2 to encourage them to do their shopping there. For awhile, it was the only store in the village. (Courtesy Savage Historical Society.)

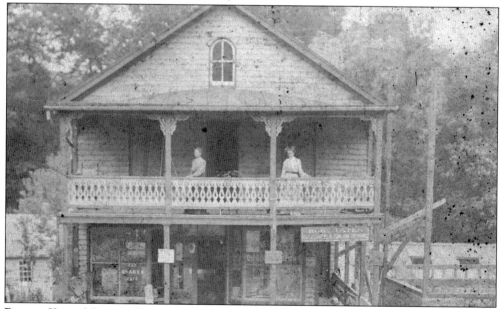

ROBERT YATES MARKET, ELLICOTT CITY. Located on Main Street in Ellicott City, this general store was owned by Robert G. Yates, who had operated a nursery business on this site in 1875. This early view of the building shows the market during the time the row of townhouses that now stand to the right were being constructed. (Courtesy HCHS.)

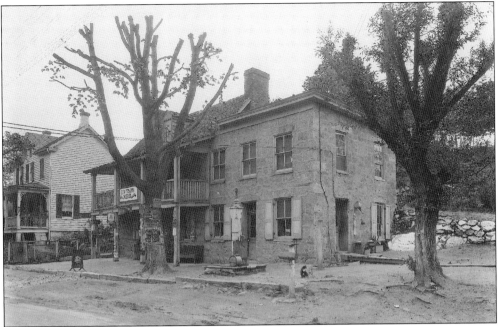

EDITH TITTSWORTH GROCERY, ELLICOTT CITY. In the 1920s, at a time when American women had only recently won the right to vote, Edith D. Tittsworth was running her own grocery store on the Frederick Turnpike in what is now the west end of Main Street in Ellicott City. Her husband, D. Thomas, had his own plumbing shop. (Courtesy HCHS.)

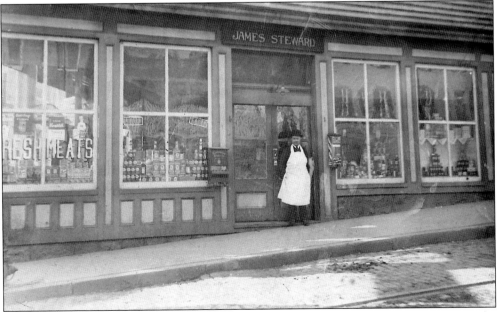

JAMES STEWARD GROCERY, ELLICOTT CITY. Conveniently located along the trolley line near the corner of Main Street and Columbia Pike, James Steward's grocery store offered a wide range of food and other goods. He and his wife, Mary, along with their children James Jr., John, and Margaret, lived above the store in a three-story building that was torn down in 1925 to make way for a filling station. (Courtesy HCHS.)

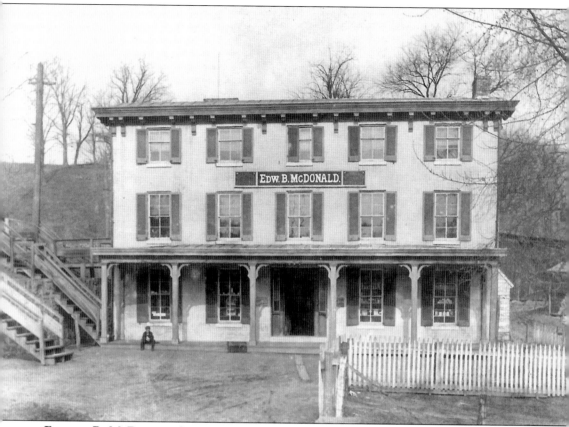

EDWARD B. McDONALD GENERAL STORE, OELLA. Erected in 1833, this once-stuccoed brick and stone building, which stands across the Patapsco River Bridge from Ellicott City, began its commercial life as a tavern and country inn. The steps to the left led up to the trolley tracks that ferried travelers between Catonsville Junction and Ellicott City from 1898 to 1955. During the Prohibition era, it became a confectionery and dry goods store. In 1948, it returned to its roots as a tavern that was know for much of the 20th century by its colorful nickname and raucous reputation as "the Bloody Bucket." In 1972, the Hurricane Agnes flood destroyed the lower floor. Owners restored the building and began serving sandwiches and chili. Today, the business is operated as a full-service restaurant and bar called the Trolley Stop. (Courtesy HCHS.)

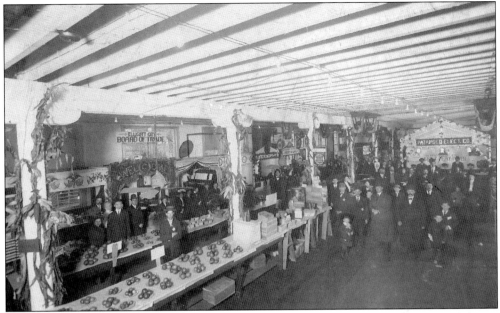

ELLICOTT CITY BOARD OF TRADE. Decorated in a fall harvest theme, this unidentified exhibition hall features booths promoting various 1920s-era businesses and merchants, including John Kirkwood's Shoe Store, J. Dickey and Sons textile mill, and the Patapsco Electric Company, as well as produce and other wares. Modern amenities, including electric lights and a telephone pay station, helped make this early convention a commercial success. (Courtesy HCHS.)

GOING IN STYLE. Over the years, Ellicott City has been home to a number of funeral parlors. William Fort's was one of the earliest. In 1880, his business was taken over by Daniel Laumann and Clinton Easton. By the 1920s, Easton's son Milton and grandson Clinton were able to add a fleet of ambulances like the one pictured here, which they used to transport patients to hospitals and nursing facilities. (Courtesy HCHS.)

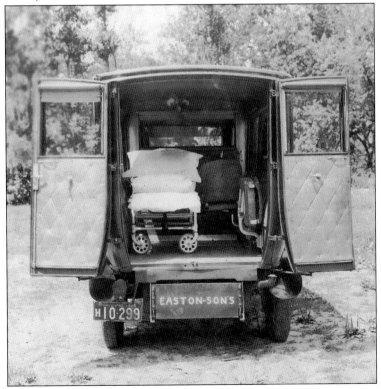

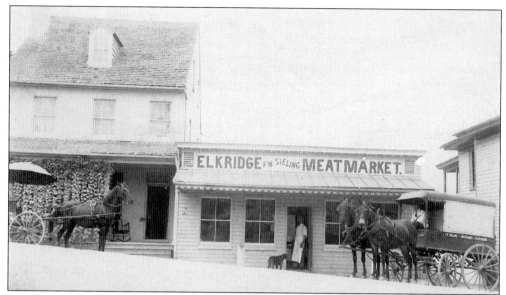

ELKRIDGE MEAT MARKET. In 1908, the 32-year-old German-born Frederick William Sieling was in business for himself, butchering meat and delivering it to the kitchens of wealthy Elkridge area families living in Lawyers Hill and the surrounding area. He may have saved some of the best cuts for himself in order to make sauerbraten, or "sour beef," a marinated German-style pot roast that is still popular in the Baltimore region today. (Courtesy HCHS.)

ROLAND H. MULLINIX AND SONS. Dating back seven generations in Howard County, this family farm switched from raising dairy cows to beef in the 1940s and was one of the largest full-scale cattle operations in the county. Today, the Lisbon farm's income comes from selling fertilizer, growing field corn (for animal feed) and soybeans, and buying, storing, and selling grain from other growers. (Courtesy HCHS.)

WAITING FOR THE MILK TRAIN, 1912. Solopha farmhand Arthur Dorsey waits for the B&O milk train with a wagon filled with five and seven gallon cans of milk drawn by him and others from cows back at the farm. The small frame station seen here was located between the railroad tracks and the Patapsco River, one mile northeast of Solopha, where Dorsey lived and worked for the Warfield family. (Courtesy H. Branch Warfield.)

WOODBINE CANNING FACTORY, C. 1936. In operation during the 1920s and 1930s, the Woodbine Canning Factory canned local corn, peas, and tomatoes. Damaged in a fire that swept through the town in June 1933, the factory became a paper mill in the 1950s. The home of Ethel Bidingers can be seen in the background. (Courtesy HCHS.)

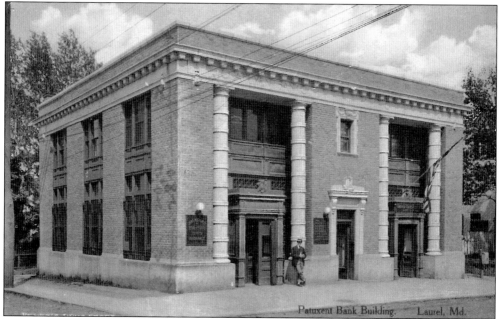

PATUXENT BANK, LAUREL. The town of Laurel began in 1811, when the Snowden family built a gristmill on the banks of the Patuxent River. The town grew with the opening of a Baltimore to Washington rail line and the expansion of the Patuxent Manufacturing Company in 1835. In the years after its incorporation in 1870, the town saw handsome banks like this one spring up along its bustling Main Street. (Courtesy HCHS.)

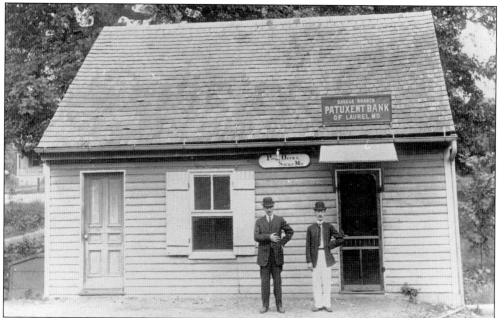

SAVAGE POST OFFICE. Located near the corner of Washington and Foundry Streets on a plot commonly known as Yankee Hill, this photograph of the building that served as both the post office and the Savage Branch of the Patuxent Bank of Laurel, Maryland, was taken sometime after 1914 when Dallas Waters began serving as postmaster. (Courtesy Savage Historical Society.)

HIGHLAND SAVINGS BANK. Founded in 1906 by Harold Hopkins and located in a corner of Rannie's store until this building was completed in 1908, the bank was one of only two in existence in Howard County at the time. Constructed at a cost of less than $2,500, the original stone building located next to Boarman's was later used as a residence, an antique store, and Smeeta's Pharmacy. (Courtesy Mildred Disney Gallis.)

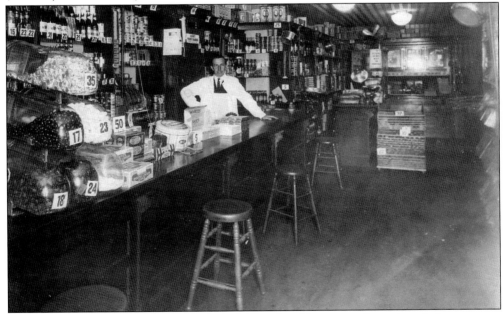

ELLICOTT CITY STORE, c. 1920s. Shop clerk Theodore France stands ready to help customers behind the counter of this Ellicott City store that is described as "the second store from the depot yard" on Main Street. The big numbers on the tags are the prices of the wares on the shelves and the candies and cakes on the counter. Dessert lovers could buy an entire Ward's Layer Cake for just 50¢. (Courtesy HCHS.)

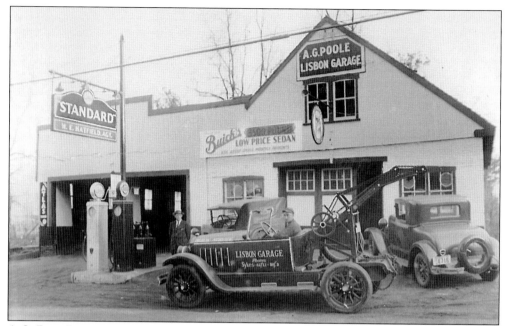

A.G. Pool Buick Agency, Lisbon. Listed as a car salesman in the 1920 census, Arthur G. Poole sold Buicks, serviced cars, and sold gas at this station, likely located along the National Road in Lisbon. Motorists whose cars broke down out in the wilds of the western county could have their car towed in by this truck, which is shown being driven by shop machinist Charles Pickett as Poole looks on. (Courtesy HCHS.)

Green Gables Cottages, West Elkridge. Located 10 miles from Baltimore and 30 miles from Washington, DC, on Route 1, this was a roadside sleepover stop for weary travelers journeying along what was then the East Coast's only major north-south highway. A. Anderson owned this cluster of modern cabins and a restaurant in the 1930s. Reservations could be made by dialing Elkridge 34. (Courtesy HCHS.)

Six

THE LOVELY HOMES

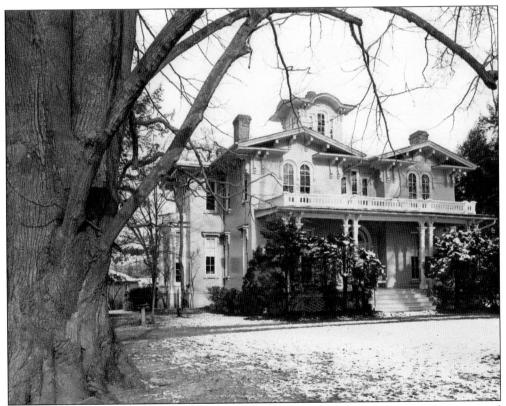

TEMORA, ELLICOTT CITY. In 1857, noted architect N.G. Starkwether designed and constructed this Victorian Italianate mansion for the family of Dr. Arthur Pue Jr., a descendant of the Caleb Dorsey family. The outer walls, although of frame construction, are finished to imitate the appearance of masonry, similar to the technique used at Mount Vernon. This was the 1984 HEC Show House. (Courtesy HCHS.)

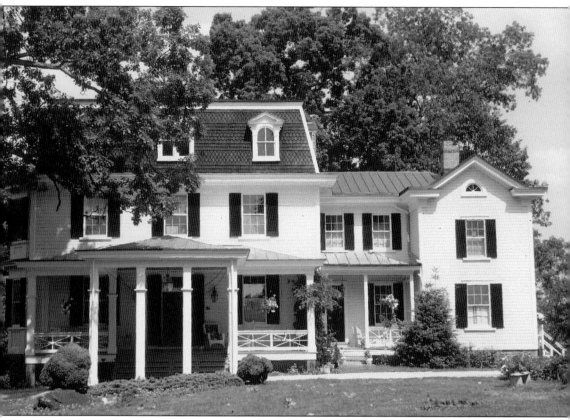

MacAlpine, Ellicott City. This lovely Second Empire–style home was built around 1860 by James Mackubin, one of Maryland's leading lawyers, for his second wife, Gabriella Peter Mackubin, the great-granddaughter of Martha Washington. According to legend, Gabriella was unhappy at Grey Rock, the home James had shared with his first wife, Comfort Dorsey, because upon awakening each morning she looked out on Comfort's grave. The Civil War broke out shortly after the couple moved into their new home, and Mackubin struggled to cultivate and retain the land. Worrying about the constant threat of having his crops, horses, and food confiscated by troops moving through the area, the Mackubins sold everything and moved away. This was the 1985 HEC Show House. (Courtesy the Celia Holland Papers, Special Collections, University of Maryland Libraries.)

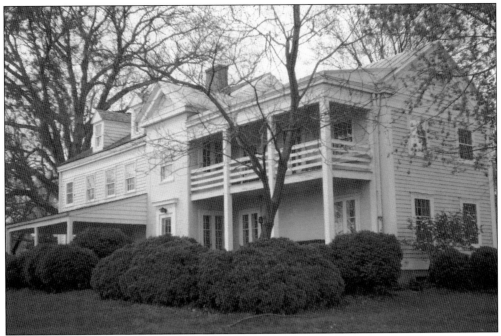

PATERNAL GIFT FARM, HIGHLAND. Named so because Maj. Charles Alexander Warfield acquired the land as a gift for his son Dr. Gustavus Warfield, this home sits on the original tract, patented in 1803, which then consisted of 510 acres. Erected sometime before 1860, this large frame home is built in the classical style of the Colonial farmhouses of upstate New York. This was the 1986 HEC Show House. (Courtesy the Celia Holland Papers, Special Collections, University of Maryland Libraries.)

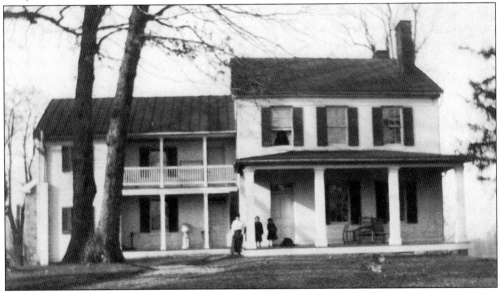

WHEATFIELD, ELLICOTT CITY. In 1695, a tract of land was patented to Samuel Chew as Chew's Resolution Manor and Chew's Vineyard, which was acquired by Caleb Dorsey in 1718. The first structure, which may have been a summer home, was built around 1802 and is an example of what is known as a "telescopic" house. This was the 1987 HEC Show House. (Courtesy HCHS.)

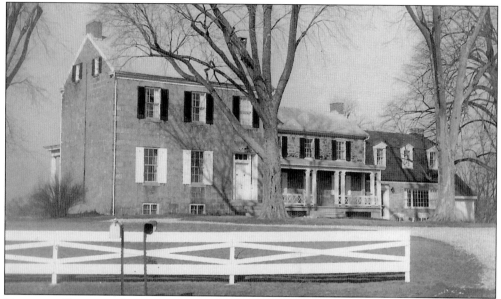

BETHESDA, COLUMBIA. Begun in 1682 as a summer home for Maj. Edward Dorsey, the house was acquired by Elk Ridge ironmaster Caleb Dorsey, who deeded it to his daughter Mary in 1771. Mary and her husband, Dr. Michael Pue, established the home for themselves and their 10 children. Inspired by the family's four generations of doctors, the name means "a place of healing." This was the 1989 HEC Show House. (Courtesy the Celia Holland Papers, Special Collections, University of Maryland Libraries.)

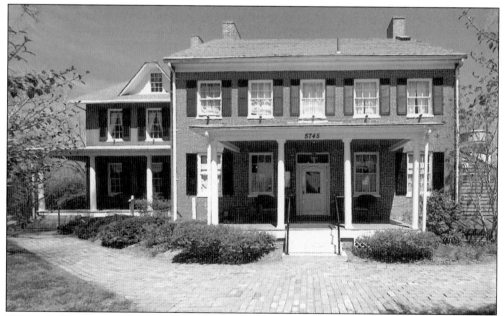

ELKRIDGE FURNACE INN, ELKRIDGE. Built on land resurveyed by James McCubbin in 1744 and acquired by Caleb Dorsey for his iron furnace, this exceptionally fine Federal-Greek Revival house was likely built in 1835 by the furnace's owners, John and Andrew Ellicott. Spared from destruction in the great flood of 1868, today it welcomes visitors as an upscale restaurant on the banks of the Patapsco. This was the 1991 HEC Show House. (Courtesy Donald W. Reichle.)

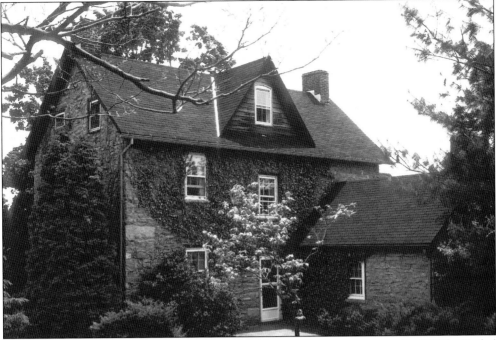

DISCOVERY FARM, GLENELG. Standing on a part of Second Discovery, patented in 1729 by Vachel and Joseph Howard, this charming and quaint fieldstone dwelling features a kitchen that is the oldest part of the house, dating to around 1760. The foundation of the old slave quarters stands close to the house and now surrounds a vegetable garden. This was the 1993 HEC Show House. (Courtesy the Celia Holland Papers, Special Collections, University of Maryland Libraries.)

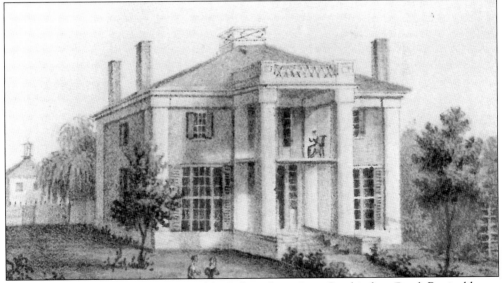

MOUNT IDA, ELLICOTT CITY. Designed by Robert Carey Long Jr., this fine Greek Revival home was built for the grandson of Andrew Ellicott in 1828. The last house to be built in the historic district for a member of the Ellicott family, it later became the home of the Judge John Snowden Tyson family. His daughter Ida lived there until she died at age 90. This was the 1995 HEC Show House. (Courtesy Library of Congress.)

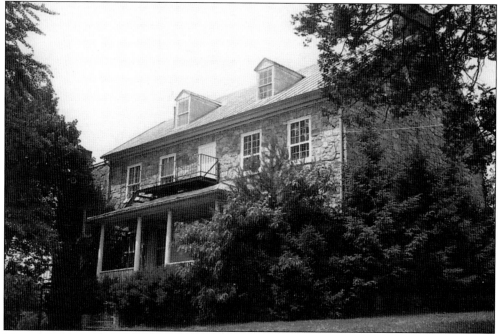

MOUNT HEBRON, ELLICOTT CITY. Col. John Worthington Dorsey, commander of the Maryland Elk Ridge Militia of the Revolutionary War, built this substantial stone home in 1808 for his son Thomas Beale at the time of his marriage. While serving as chief justice of the court of appeals from 1848 to 1851, Judge Dorsey was primarily responsible for Howard County becoming Maryland's 21st county. This was the 1996 HEC Show House. (Courtesy the Celia Holland Papers, Special Collections, University of Maryland Libraries.)

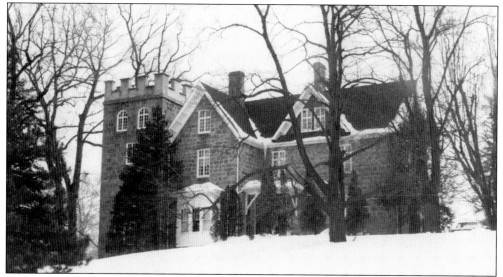

LILBURN, ELLICOTT CITY. Built in 1857 by Englishman and Baltimore iron magnate Richard Henry Hazelhurst, this brooding 20-room Gothic Revival mansion with its Romanesque tower is thought to be haunted by him as well as one of his daughters. Damaged by a fire in 1923, the home is much modified. See page 103 for pre-fire photographs. This was the 1997 HEC Show House. (Courtesy the Celia Holland Papers, Special Collections, University of Maryland Libraries.)

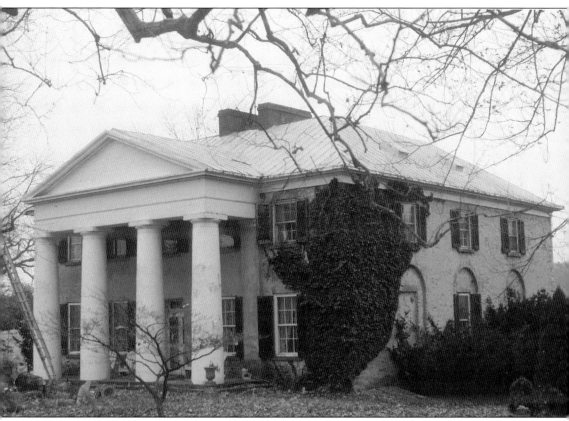

FOLLY FARM, ELLICOTT CITY. Quartered off Doughoregan Manor, this unique property was the farm portion of Folly Quarter. Believed to have been originally constructed around 1730, this eclectic Georgian, Romanesque, and Greek Revival building was modified by Charles Carroll around 1800 to include a circular chapel, complete with a small priest's dressing chamber. In addition to the chapel, Carroll built a large spring-fed marble bathing pool in the cellar. The original kitchen once boasted three fireplaces with separate flues, two of which are thought to have been used to vent back ovens. Under the house, there are three dungeon-like cubicles that at one time were only accessible by individual trapdoors. Additional alterations were made when Carroll gave the home to his favorite granddaughter, Emily Caton MacTavish, to live in while they built the Folly Quarter mansion for her. This was the 1999 HEC Show House. (Courtesy HCHS.)

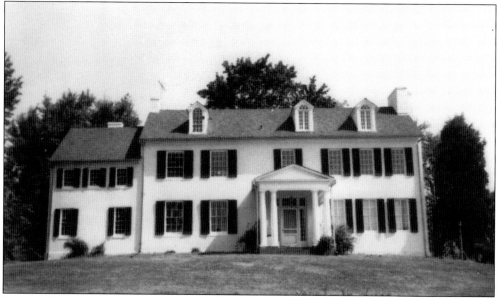

DORSEY HALL, ELLICOTT CITY. This house, from the pre–Revolutionary War era, is built on land patented by the Honorable John Dorsey (thought to be the youngest son of the immigrant Edward Dorsey) as Dorsey's Search. A good example of stone and brick vernacular architecture of the 18th and 19th century, it was constructed in at least four sections over 200 years. This was the 2001 HEC Show House. (Courtesy HCHS.)

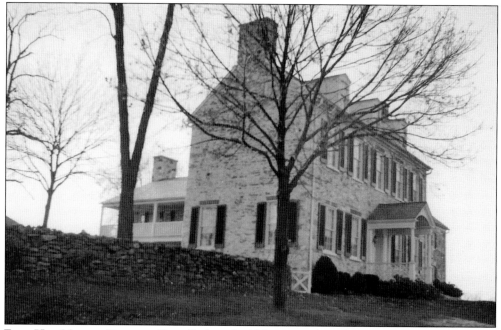

FONT HILL MANOR, ELLICOTT CITY. Built in the 18th century by Admiral Hammond on a portion of land patented by Daniel Kendall as Kendall's Delight in 1701, this outstanding stone home began as a modest structure that was significantly enlarged during the 19th and 20th centuries. Outbuildings on the property are thought to be former slave quarters, and the fieldstone fence is said to have been built by slaves. This was the 2004 HEC Show House. (Courtesy HCHS.)

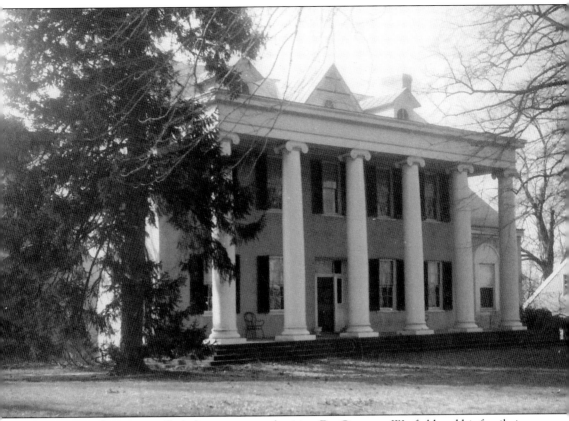

LONGWOOD, GLENWOOD. Built for prominent physician Dr. Gustavus Warfield and his family in 1818, this stately stone manor has often been referred to as Howard County's first hospital because the doctor would sometimes keep very ill patients overnight in the loft over his office. He and his wife, Mary, raised eight daughters and one son, Evan William, who carried on in the medical profession of his father and his grandfather Charles Alexander Warfield. The smokehouse is the only survivor of the early-19th-century domestic outbuildings. South of the house is an old slave burial ground that contains a tombstone inscribed as follows: "To Our Faithful Nurse Peggy Fosset. Born 18, January 1795. Died 25 June 1865. By Mr. & Mrs. Warfield and their children. Longwood." This was the 2005 HEC Show House. (Courtesy the Celia Holland Papers, Special Collections, University of Maryland Libraries.)

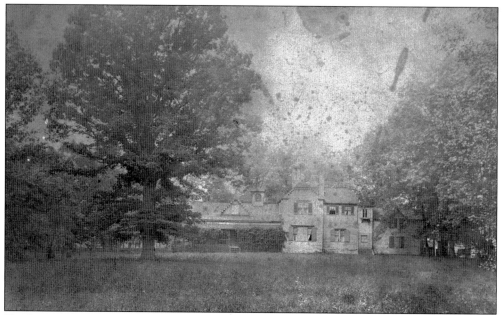

THE LAWN, ELKRIDGE. The construction of the new B&O Railroad line from Baltimore to Ellicott's Mills in the 1830s made it convenient for Baltimore residents to build summer cottages in Elkridge and Ellicott City. Built by Baltimore attorney and judge George W. Dobbin in 1835, this home is one of many constructed by other attorneys on what became known as Lawyers Hill. This was the 2006 HEC Show House. (Courtesy Maryland Historical Society.)

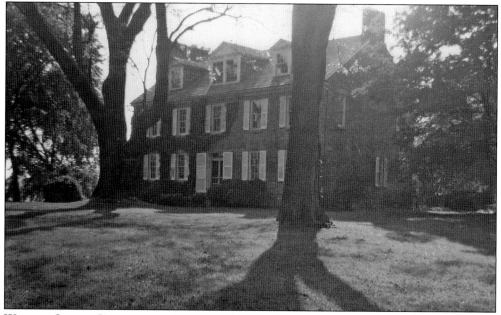

WALNUT GROVE, CLARKSVILLE. Constructed around 1780 on land originally owned by Thomas Browne of Browne's Chance and Dorsey's Friendship, this stone manor was the home of Col. Gassaway Watkins of the Army of the Revolution. Edwin Warfield, grandson of Colonel Watkins, later purchased the home. Watkins and his third wife, Eleanora, are buried in a cemetery on the property. This was the 2009 HEC Show House. (Courtesy HCHS.)

Seven

FACES AND PLACES

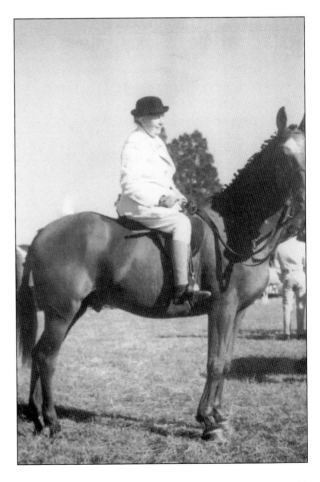

ALDA TYSON HOPKINS CLARK OF KEEWAYDIN. In addition to being the wife of the Honorable James Clark Sr. and an ardent Howard County preservationist, Alda Clark was a noted horsewoman and member of the Howard County Hunt Club. She, her husband, and their three sons, including Maryland state senator James A. Clark Jr., lived at Keewaydin Farm on Columbia Pike in Ellicott City. (Courtesy HCHS.)

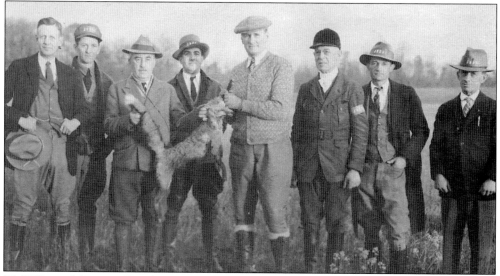

"6 O'CLOCK MORNING FOX CAUGHT." This is the inscription scrawled on the back of this 1928 photograph of the Howard County Hunt Club. The judges are listed as, from left to right, A. Riggs, F.S. Bradley, C.L. Gilpin, J.P. Smith, Walter Johnson, J.M.R. Lewis, K. Hobbs, and R. Curran. They display the results of a successful hunt. (Courtesy HCHS.)

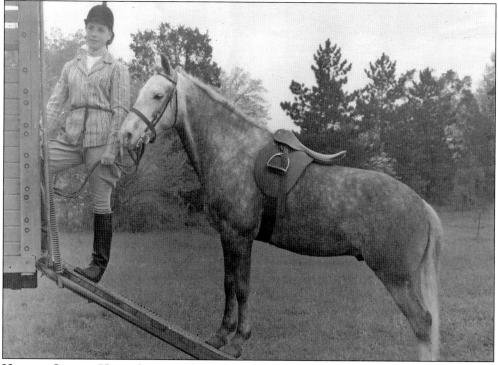

HOWARD COUNTY HORSE SHOW. In the early 20th century, Doughoregan Manor was the site of this annual charity fundraising event. As reported in the May 29, 1932, issue of the *Baltimore Sun*, "Drawn by the sparkling weather and the unusually large number of stellar entries, a gallery of 2,500 turned out for the Tenth Annual Howard County Horse Show." Shown are Kathy Stevens and her pony Impossible Grey. (Courtesy HCHS.)

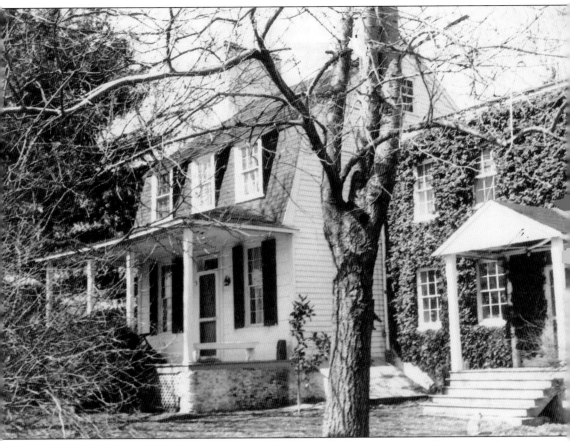

PEACEFIELDS. Also known as Round About Hills, this perfectly preserved small plantation house is one of the county's oldest homes. It stands on the east side of Route 97, on the remainder of a tract of 266 acres that was patented to Henry Ridgley, surveyor, on November 15, 1745. Built by the Ridgelys in the late 1740s, the oldest part of the home, with its gambrel roof and steep dormers, is distinguished by its unusual stone ends with front and back frame connecting walls. The stone wing was added in 1820 and houses the kitchen, a dining room, and two upstairs rooms. In 1771, the homestead was sold to Reuben Meriweather of Annapolis who, along with his wife, Sarah Dorsey, raised eight children there. In 1839, the property was exchanged for the Cooksville estate of Thomas Cook. (Courtesy the Celia Holland Papers, Special Collections, University of Maryland Libraries.)

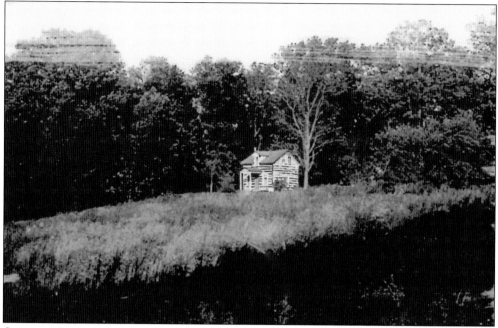

CRAPSTER FARM LOG HOUSE. Also known as Thaddeus Crapster's Log House, this simple two-room structure in Woodbine dates to the early 19th century. Thaddeus purchased the house along with 125 acres from his father, Mortimer D. Crapster, in 1919 and lived there for many years. (Courtesy the Heckman family.)

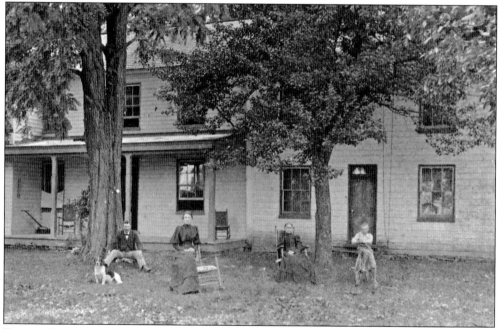

POPLAR SPRINGS, C. 1900. Around 1900, August Riggs Stackhouse posed for this photograph with his family on the lawn of his farmhouse in Poplar Springs. He is pictured here at the far left with, from left to right, his daughter Georgia Virginia Webb; his wife, Emily Burdette Stackhouse; and his grandson William "Billy" Webb. (Courtesy Philip E. Stackhouse.)

WILLIAM "OLE BILL" GREEN, 1940. Running a large farm required hired help who often lived with the families they worked for. One of them was Bill Green. He milked cows, gardened, chewed tobacco, and mesmerized the Warfield children with stories of headless ghosts. He lived in a room above the kitchen in the family's home at Solopha. (Courtesy H. Branch Warfield.)

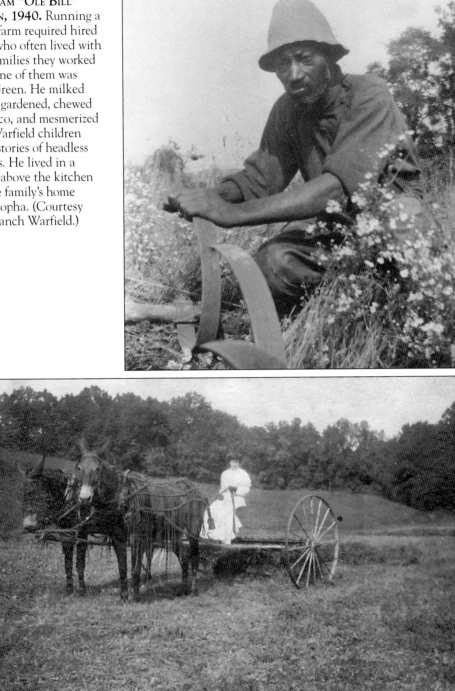

LORENA RIDGELY, C. 1890s. Pictured perched on a buggy in a crisp white dress at the family's Bowling Green Farm, Lorena Ridgely is not likely to have been out cultivating fields. The mules, however, are dressed for work in their fringed leather fly sheets, designed to keep biting insects at bay. (Courtesy the Ridgely Jones family.)

EASTWICK FARM, C. 1940S. Located on Carrs Mill Road in Woodbine, this 160-acre property was purchased by the Dowd family in 1953 and operated as a dairy farm with a herd of over 100 cows. Renamed the Circle D Farm, part of the property is now a venue that hosts a day camp, company picnics, parties, and weddings. (Courtesy Dowd family.)

ROCK-A-BYE BABY. Propped up by plump pillows in the basket of a wicker dogcart, little John R. Jones is pictured in front of the barns and fields of the family homestead near Sykesville. John, along with his brother Phil, would grow up to continue their father's successful dairy operation, which continues today as both a farm and a provider of fresh local cheeses. (Courtesy the Ridgely Jones family.)

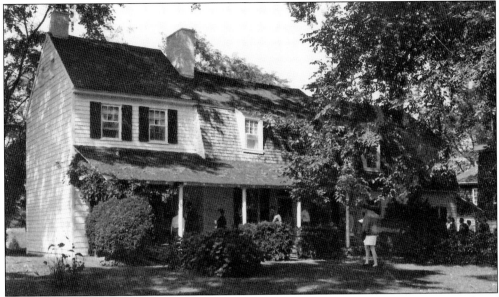

CHERRY GROVE. Revolutionary War captain Benjamin Warfield built this charming hipped-roof house shortly after 1766, when he purchased the 550-acre land grant known as Fredericksburg that had been laid out by Henry Griffith. Located on Jennings Chapel Road in what is today known as Woodbine, this three-sectional house features outstanding cherry paneling that may have been milled from the grove of its namesake cherry trees. (Courtesy HCHS.)

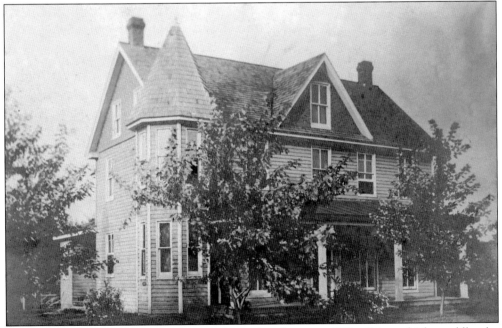

TITTSWORTH FAMILY HOME. This home is located in the town of Woodbine, which straddles the Patapsco River south into Howard County and north into Carroll County. During the Civil War, it is said that the rebel cavalry crossed here, scouting the Union army on its way to the Battle of Gettysburg. Members of the Tittsworth family were known to be living in this area at the time of the 1880 federal census. (Courtesy HCHS.)

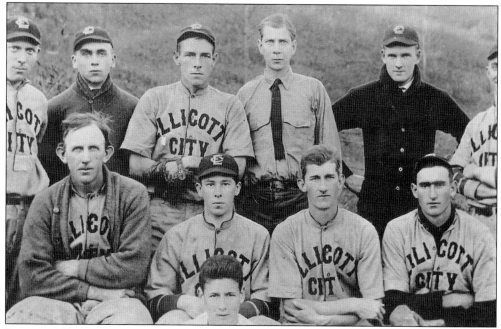

LOVE AND BASEBALL. Baseball became increasingly popular in the early 1900s. Almost every community had its own team, including this group of unidentified players from Ellicott City. The baseball team is not the town's only claim to baseball fame. It was here at St. Paul's Church that George Herman "Babe" Ruth married his first wife, Helen Woodford, on October 17, 1914. (Courtesy HCHS.)

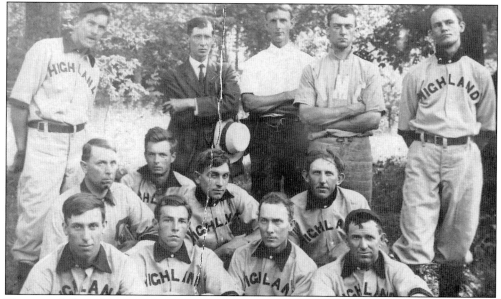

HIGHLAND'S IRON MAN. In 1908, this team won the Howard County championship. It was led by "Iron Man" Malcolm Disney (first row, second from the left), who began playing in 1905 at the age of 16 and missed only two games between then and when he quit playing at age 61. When not on the field, Disney operated the Highland Garage at Route 108 and Highland Road. (Courtesy Mildred Disney Gallis.)

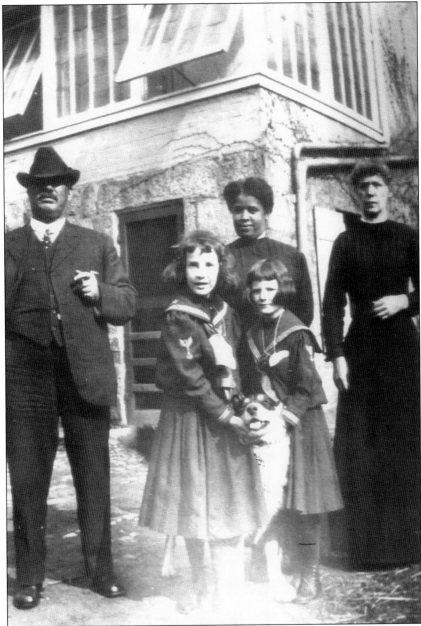

UPSTAIRS, DOWNSTAIRS, ELLICOTT CITY. With employment listed as "own income" on the 1910 federal census, Englishman Albert H. Weld was more than wealthy enough to staff his Hazeldene/Lilburn mansion with a number servants. After Nannie, his wife, passed away of a brain tumor on June 2, 1911, Weld needed additional help to care for his two young daughters, Mary Katherine and Elizabeth Mary. Here, the girls and their dog Bingo pose a few years later outside the conservatory with an unidentified man, servant Rachael Carter, and Irish nurse Annie Cusie. Other servants listed as living at the mansion at the time of the 1910 census were "mulatto" servants Albert Redmond, Joseph Randolph, and his wife, Willie, who was the cook. After Weld passed away in 1921, the home was sold and the teenaged girls were sent abroad to Europe. (Courtesy Keller-Weld family.)

SAVAGE SUNDAY STROLL, 1900S. Possibly because the roads were dusty and the train tracks were relatively clean, promenading down the Savage switch of the B&O Railroad was a popular thing for the townsfolk to do on Sunday afternoons. Here, Walter and Lula Phelps show off their finery after church. (Courtesy Savage Historical Society.)

EASTON FAMILY SURREY RIDE. Ellicott City undertaker Milton Easton also ran a livery in a stable behind his Main Street funeral parlor. Here, wife Grace, son Clinton, and daughter Beulah get ready to head out in a little fringe-topped surrey pulled by their prize-winning horse Babylon. Milton Easton is in the background, perhaps hurrying to get into the picture. (Courtesy HCHS.)

SIELING FAMILY AT OAK HALL. German-born farmer Johann Sieling is seen with various relatives at their home at Oak Hall. Here, they are pictured in their finery, from left to right, (first row) Anna Bormann, Johnny, and patriarch Johann; (second row) Anna A. Sieling, Henry, Frederick Willie, and Elise M. Sieling. (Courtesy HCHS.)

SPECIAL DELIVERY. In earlier times, owners of large plantations would provision their tables with livestock they raised or wild game they hunted on their properties. But by the late 1800s, commercial ice companies made it possible to ship meat raised elsewhere to wealthy families. Here, Johnny Sieling delivers a crate of iced meat to Oak Hall from the family's F.W. Sieling's Meat Market in Elkridge. (Courtesy HCHS.)

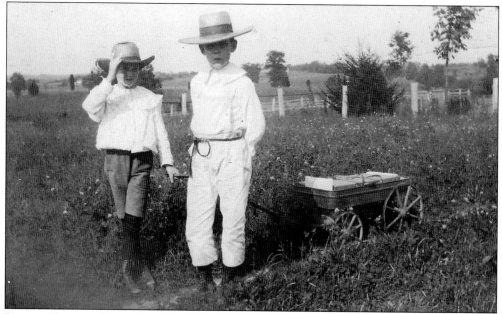

BOYS OF SUMMER. Born in 1848, William Vernay rented a farm in the southeastern part of the county. He lived there with his wife, Kate; various family members; and servants. One of these two dapper-looking young boys in this 1890s photograph is likely to be either Vernay's son Fredie, born in 1885, or his nephew Benjamin, born in 1887. The other is an unidentified St. Clair boy. (Courtesy HCHS.)

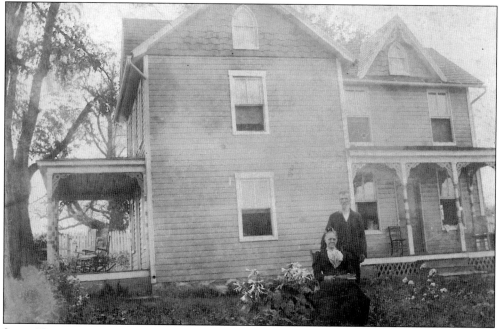

SELBY HOME ON IVORY ROAD. Located along what is now Route 32, this Carpenter Gothic frame home was owned by Nicholas and Francis Selby. Born in 1839, Nicholas was the eldest son of Enoch and Flavilla Selby, who raised Nicholas and his siblings Mary, Samuel, Jane, John, and Joseph in Howard County during the second half of the 19th century. (Courtesy HCHS.)

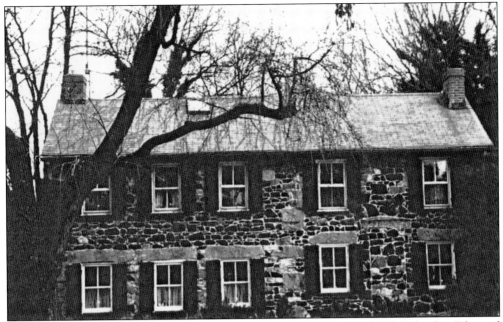

SEARCH ENCLOSED. This stone house, located nearly at the corner of Old Columbia Pike and Route 103, was the home of the station master of a privately owned weighing station started by John L. Clark, grandfather of Sen. James Clark. Farmers would stop here to check the weight of their grain before taking it into Ellicott's Mills to sell. (Courtesy HCHS.)

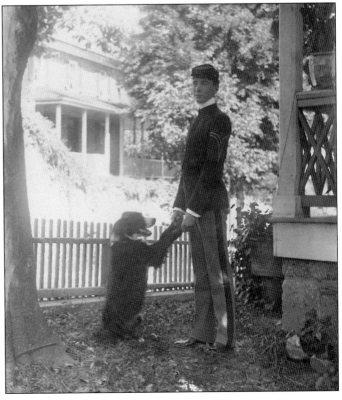

GAITHER HUNTER SYKES, c. 1903. Born in 1885, Gaither Hunter Sykes was the son of Ellicott City dentist Mordeci Sykes. Seen here in his Virginia Polytechnic Institute uniform in the yard of a home along Fells Lane, Sykes studied to become a civil engineer. He married Marie Barton Beck of Baltimore on June 6, 1917, and for a time he and his bride lived with his parents in Ellicott City. (Courtesy HCHS.)

SUNDAY AFTERNOON IN SAVAGE. Dressed in their Sunday best, this group of unidentified men and a small boy may have just left services at the Methodist Episcopal Church North behind them. At the time this c. 1920s photograph was taken, air-conditioning in churches was many decades away, so parishioners used fans, such as the one held by the man in the cap, to stay cool and comfortable. (Courtesy Savage Historical Society.)

MOTHER GOOSE MATTHEWS. Between 1966 and 1991, retired Howard County schoolteacher Marian Matthews, dressed as "Mother Goose," delighted children with weekly readings at the Savage Library at the Carroll Baldwin Community Hall. She was 81 when she finally closed her storybook, shortly before the new library opened at the corner of Knight's Bridge and Gorman Roads. (Courtesy Savage Historical Society.)

Eight

SELDOM SEEN

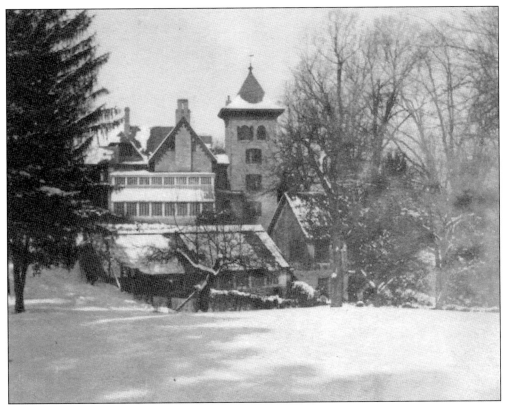

HAZELDENE/LILBURN. Between 1906 and 1922, this was the home of Albert and Nannie Weld and their two daughters, who renamed Lilburn as Hazeldene. In 1923, the home was purchased for $20,000. Later that year, the Christmas tree in the front parlor caught fire and burned most of the original interior, as well as the two-story conservatory and the Gothic-spired tower roof, which was replaced with its current crenellated belfry extension wall. (Courtesy the Weld-Keller family.)

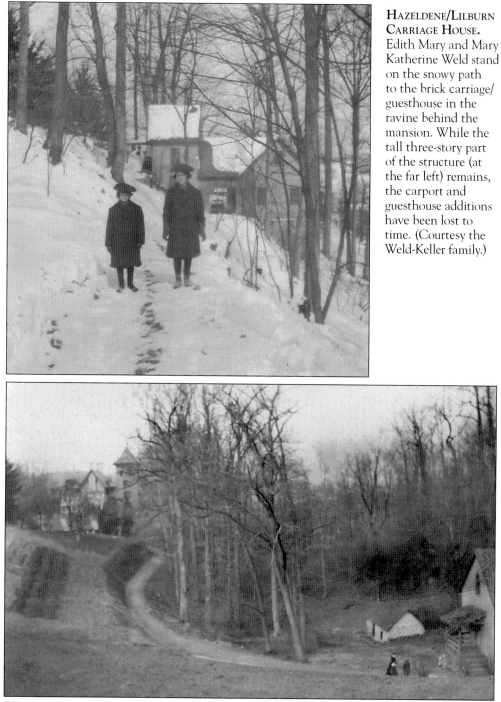

HAZELDENE/LILBURN CARRIAGE HOUSE. Edith Mary and Mary Katherine Weld stand on the snowy path to the brick carriage/guesthouse in the ravine behind the mansion. While the tall three-story part of the structure (at the far left) remains, the carport and guesthouse additions have been lost to time. (Courtesy the Weld-Keller family.)

COLLEGE AVENUE AREA ABOVE HAZELDENE/LILBURN. By the early 20th century, the original Lilburn estate, which encompassed 2,600 acres and was part of the land grant known as the Valley of Owen, had dwindled to 50 acres. This photograph, with a view of the southern side of the mansion, includes a lane winding down to a guesthouse from a higher vantage point, which today is College Avenue. (Courtesy the Weld-Keller family.)

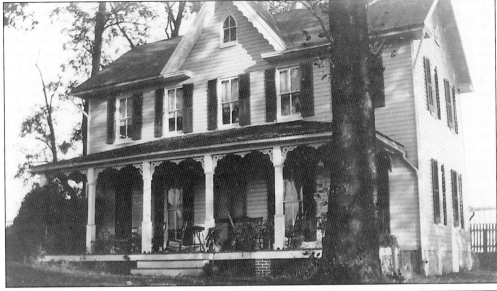

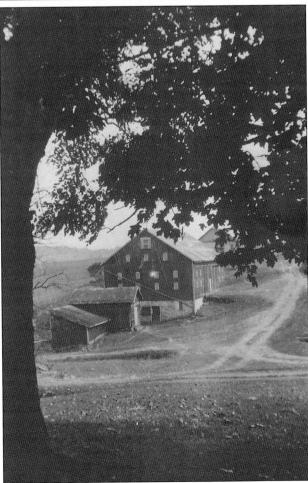

SOLOPHA FARMHOUSE AND BANK BARN. Located along the Patapsco River near Sykesville, Solopha sits on land granted to John Johnson in 1742 near a tract called Saliopa. The oldest part of the house is a log structure that dates to 1718, which was then greatly enlarged by Vachel Dorsey in 1762. In 1829, Charles Alexander Warfield purchased the home from his father-in-law for $2,400. The main section of the house was constructed in 1889 in the then popular Gothic Revival style. Solopha is the home where Joshua Dorsey Warfield Sr., a prominent Howard County Democrat and an early county commissioner, was born and raised. Many have speculated on the origins of the name. One theory is that it might be a reference to a borough in England called Salopian, which may have been where John Johnson hailed from. However, tradition holds that it is an Indian name, the meaning of which has been lost over time. (Both, courtesy H. Branch Warfield.)

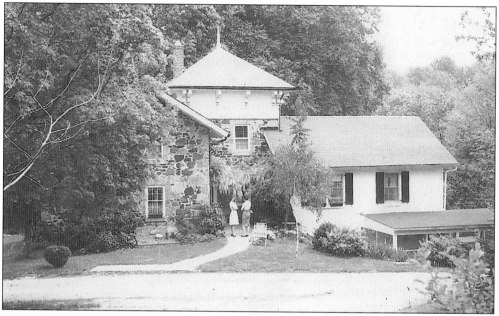

BON AIR MANOR GATE HOUSE.
Originally accessed from New
Cut Road, this charming 1870s
Romanesque cottage welcomed
guests to Bon Air Manor,
earlier known as Benson's Park.
Standing on property that was
part of an original land grant of
250 acres patented in 1696 by
Daniel Benson, the house is one
of the manor's few remaining
outbuildings, which, among others,
once included a barn, stone jail,
and slave quarters that dated
from 1805. (Courtesy HCHS.)

**SAVAGE-GUILFORD ROAD, EARLY
1900s.** Running between the
mill town of Savage and the
Commodore Joshua Barney House,
this once-country lane was lined
with light poles in the early 20th
century. Electricity came early
to the town, thanks to William
Henry Baldwin, who owned the
Savage Manufacturing Company
in partnership with his brother
Summerfield, who owned the
electric company that first brought
electricity to Baltimore. (Courtesy
the Savage Historical Society.)

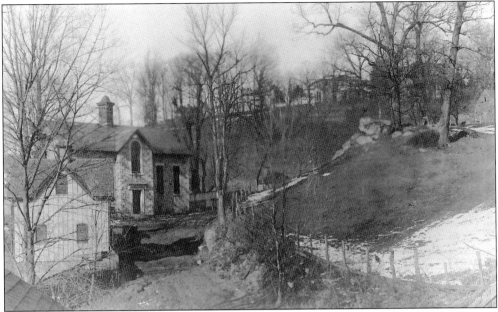

WILLOW GROVE, ELLICOTT CITY, C. 1915. Up at the end of Emory Street and next to the Howard County Courthouse stands one of the most picturesque jailhouses in Maryland. Built in 1878 and named for the graceful trees surrounding it, the Romanesque Revival jail contained eight cells, including "dark cells" where condemned men waited until the morning of their execution. The last hanging there took place in 1916. (Courtesy HCHS.)

CHURCH ROAD, EARLY 1900S. Winding up from Main Street in Ellicott City, past two churches and a parsonage, this lovely lane leads up to what was then known as Patapsco Heights at the foot of the Patapsco Female Institute. On Saturdays during the mid-19th century, it is said that "the candy man" trudged up this road and the steep hill to the school to delight the young scholars with wares from his basket of treats. (Courtesy HCHS.)

CHARLES YATES HOME, C. 1910S. Farther up Church Road is the clapboard frame home of Charles R. Yates, who was, according to 1920s census records, the owner of a confectionery in Ellicott City. Pictured in the side yard are, from left to right, "Buck," "Trim," "Tweets," and Ida Yates. (Courtesy HCHS.)

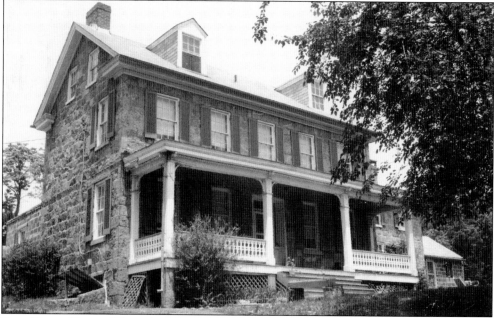

FORT-HEINE HOUSE. This substantial stone house, located just off Fels Lane in Ellicott City, was originally owned by Bernard Fort, who was an undertaker in the mid-19th century. Later, it was home to Frank Heine (who was listed as a 27-year-old telegraph operator in the 1880 federal census); his wife, Kate; and their children Mary, Frank, and Marion. Heine later became the B&O Railroad Ellicott City stationmaster. (Courtesy the Celia Holland Papers, Special Collections, University of Maryland Libraries.)

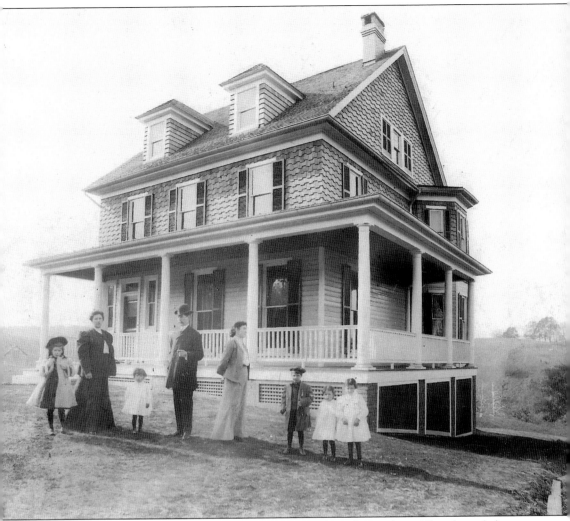

MALONE HOME AND FAMILY, C. 1910S. One of at least three Queen Anne/Shingle–style houses built by prosperous Ellicott City merchants along College Avenue as summer homes, this handsome residence was built in 1905 for saloonkeeper Edward E. Malone. He lived there into the 1920s with Mary, his wife, and their six children, Marie, William, Nellie, Edith, Hilda, Catherine, and Eugenia. Originally part of the land grant known as the Valley of Owen, this property extends back to New Cut Road. The land was likely timbered by the Hazelhurst estate shortly before it was sold, as there is not a single tree standing around the home. Later, it became the home of Granville and Constance Wehland. Much improved in recent years, the home remains in the hands of the Wehland family today. (Courtesy descendants of William J. Malone.)

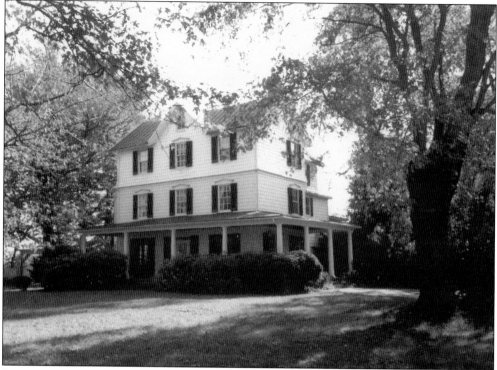

SUNNYSIDE, LISBON. Begun as a log cabin around 1800 by Joshua Warfield, son of Capt. Benjamin Warfield of Cherry Grove, the home was enlarged by Albert Warfield in 1830. In 1890, Albert's son Joshua added the front section of the house, which blends elements of Greek and Roman Revival styles. In 1930, it was owned by Norman and Clara Warfield, who lived there along with their African American servants Calvin and Mollie Woodward. (Courtesy HCHS.)

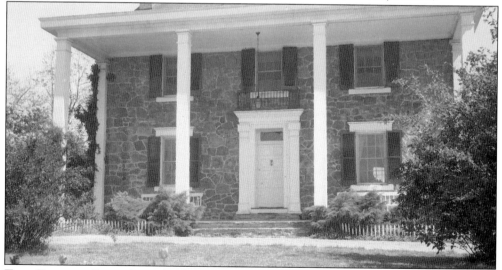

TROY, ELKRIDGE. Situated on a land grant patented to the Dorseys in the late 1600s, the original frame house on this property was home to Col. Thomas Dorsey until he died in 1790. In 1808, it was sold to Vincent Bailey along with 652 acres for $6,520. Bailey built this stone home in the 1820s. Its stabilized ruins can be seen on the hill above the I-95-Route 100 interchange. (Courtesy HCHS.)

REV. HENRY BRANCH AND THE OLD MANSE.
Constructed in 1850 as the parsonage of the
First Presbyterian Church of Howard County,
this handsome granite home is built into the
side of a hill on lower Church Road in Ellicott
City. Its first occupant was Rev. M.B. Grier,
but its best-known occupant was Rev. Henry
Branch and his family. The longest serving
pastor in the church's history, Branch began
his pastorship in 1882. Shortly afterward, in
1883, Bromwell H. Branch, the first child
to be born at the home, arrived. Although
dancing, cards, and theater were forbidden in
the household, the reverend's rambunctious
older sons are said to have used a combination
of handkerchiefs, spyglasses, and bits of mirror
to send secret messages up the hill to the girls
at the Patapsco Female Institute. Reverend
Branch is seen in this c. 1860 photograph.
(Both, courtesy H. Branch Warfield.)

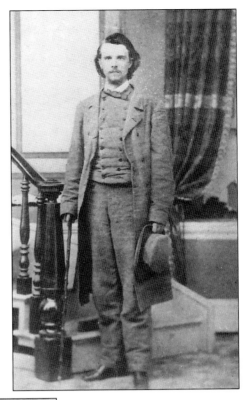

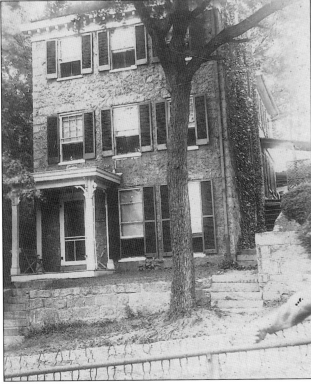

Santa Heim 1949

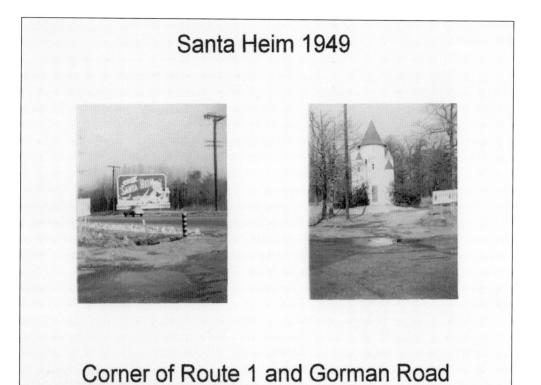

Corner of Route 1 and Gorman Road

CHRISTMAS COMES TO SAVAGE. In 1948, Harry H. Heim of Baltimore purchased the Savage Manufacturing Company to produce Christmas ornaments. There, he created a Christmas Village called Santa Heim, complete with a castle, a herd of reindeer, and a one-ring circus. Although it drew thousands of visitors the first year, the magic lasted only until October 1950, when Santa Heim closed. (Courtesy Savage Historical Society.)

ALL I WANT FOR CHRISTMAS, C. 1949. In addition to creating the fictional address of Santa Heim, Merrieland, for the mill, which drew thousands of hopeful letters to Santa, Heim had Old Saint Nick on site to take requests. Gloria Barksdale's grandmother brought her sister Shirley and her (pictured) to see the circus and to sit on Santa's lap. (Courtesy the Barksdale family collection.)

Nine

GONE BUT NOT FORGOTTEN

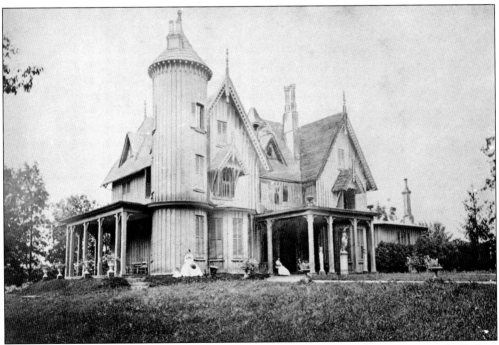

FAIRIE KNOWE, 1843–1900. Originally designed as a Gothic Revival cottage ornee by Robert Cary Long Jr. and built in 1843 for John H. Latrobe, son of the famous architect, this Elkridge home first burned in 1850. Latrobe had it rebuilt in the fanciful style of a "plain timber cottage-villa" that featured steeply pitched gable roofs, charming chimneys, and decorative cornice boards, as seen here. This second incarnation of Fairy Knowe burned in 1900. (Courtesy the Maryland Historical Society.)

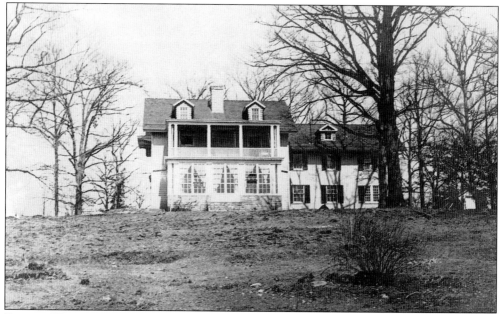

BONNIE WOOD, 1840–1929. Built by Robert Dorsey, who went on to build the historically significant Edward Stead house for his son Grafton in 1865, this frame home on Lawyers Hill was owned by a number of Elkridge families. The Daniel Murray family acquired it in 1911. The home, also known as the Miller-Murray House, was purchased by Charles A. Geatty in 1922 and burned in 1929. (Courtesy HCHS.)

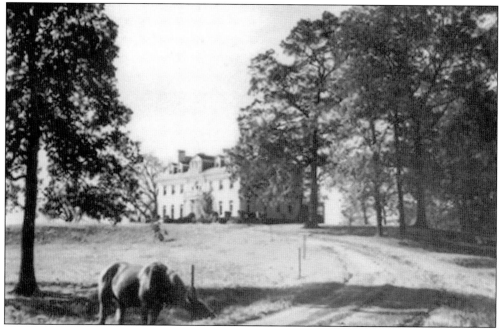

ELK RIDGE FARM, 1913–1920. Built by prosperous banker J. Booker Clark, this impressive mansion stood on what was then Cherry Lane in the town of Hilton and what is now Long Gate Shopping Center on Route 103. Estimated to be worth $225,000 at the time, this magnificent home was lost because its elevated water tank was cracked and empty at the time of the July 2nd fire. (Courtesy HCHS.)

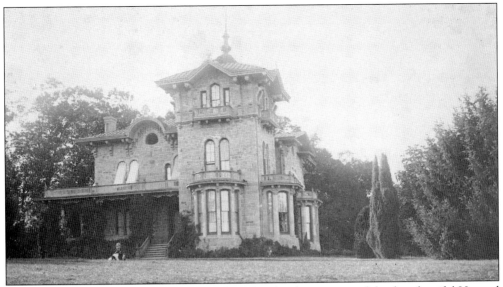

WILTON AND CHATHAM, 1850s–1930s. These lost lovelies are two of the four fanciful Howard County Italianate country homes designed by noted East Coast architect N.G. Starkwether in the 1850s. The two others that still stand are Temora and Elmonte. Wilton (above), which was located near the I-70/I-29 interchange, was built for William H.G. Dorsey. Later, it became the country home of Washington, DC, auctioneer James C. McGuire, who passed away there in 1888. From 1898 until 1931, C. Hammond Cromwell took ownership of the mansion, which boasted a magnificent winding stairway but no electricity. According to descendants, Cromwell thought it too expensive to wire. In the 1940s, it is said that rubble from the burned ruins was used for buildings at St. John's Episcopal Church, which Starkwether also designed. Chatham was home to Thomas Watkins Ligon and his wife, Mary Tolley Dorsey, daughter of Charles Worthington Dorsey. Ligon descendants sold the property to lumberman Joseph Natwick. After timbering the property, he declared that he was "dunloggin" and then established the Dunloggin Dairy Farm in the 1920s and 1930s. (Above, courtesy Bill Madden; below, courtesy HCHS.)

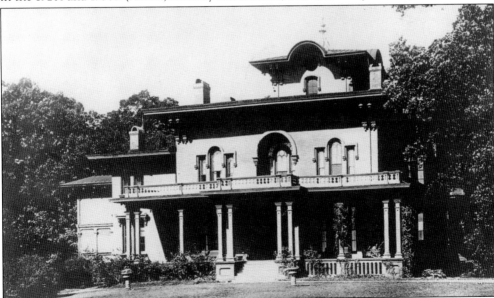

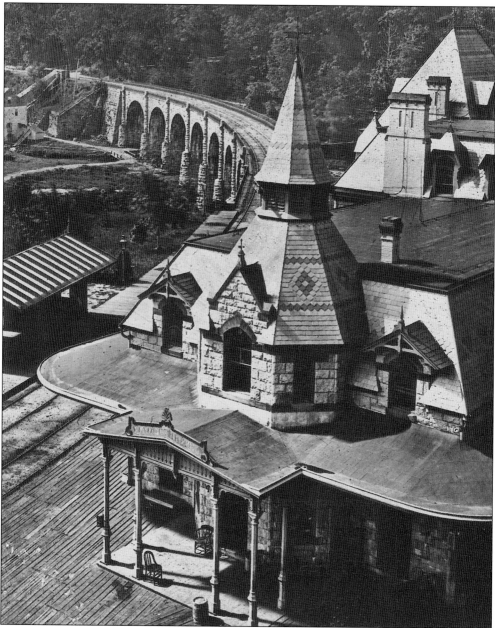

VIADUCT HOTEL, 1872–1950s. This showcase combination hotel and railroad station was built on the site of the earlier 1830s-era Relay House Hotel, which was a change point (or relay) for horses hauling the railroad cars the last six miles into Ellicott City. Commissioned by the B&O Railroad and designed by architect E. Francis Baldwin, this massive Gothic building was constructed of Patapsco granite and red seneca stone and cost $50,078.41. The two-story porch on the river side of the hotel gave visitors a breathtaking view of the Patapsco River Valley, Thomas Viaduct, and the beautiful gardens, graveled walkways, flowers, hedges, and evergreens that surrounded the building. Due to the decline in train travel, the relay station was closed in 1938 after 108 years of continuous service. The station was torn down in the 1950s. The Thomas Viaduct was declared a National Historical Landmark in 1964. (Courtesy Harry C. Eck.)

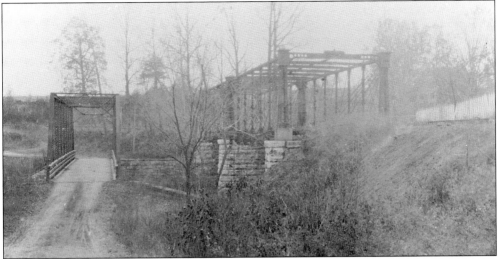

BOLLMAN TRUSS TWIN BRIDGE. While the iconic Bollman Truss Railroad Bridge across the Patuxent River has been restored and remains a Howard County landmark, its twin that once carried carriages and automobiles across and onto Foundry Street in Savage has been lost to time. This pre–World War I image is all that remains. (Courtesy the Savage Historical Society.)

MONTPELIER MANOR HOUSE, 1740–1996. Built by Col. Henry Ridgely IV, this Georgian-style mansion was located near the intersection of Route 29 and Johns Hopkins Road. The home, which was constructed of brick that was covered with scored stucco in the 19th century, featured a musician's stairway, where a small chamber orchestra would perform during parties. It burned in May 1996 and was then torn down. (Courtesy HCHS.)

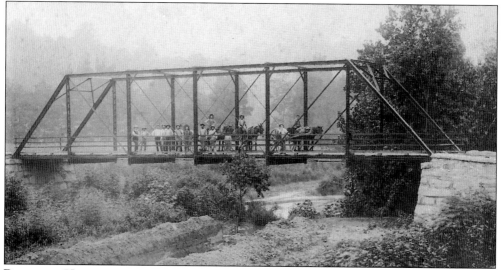

BRIDGE TO HENRYTON, 1800S–1972. Spanning the Patapsco River from Howard County to Carroll County on Henryton Road, this one-lane bridge led travelers to the Henryton State Hospital Center, formerly known as the Henryton Tuberculosis Sanatorium, which was erected in 1922 by the Maryland Board of Mental Hygiene. The bridge is said to have been swept away in the catastrophic Hurricane Agnes flood in June 1972. (Courtesy HCHS.)

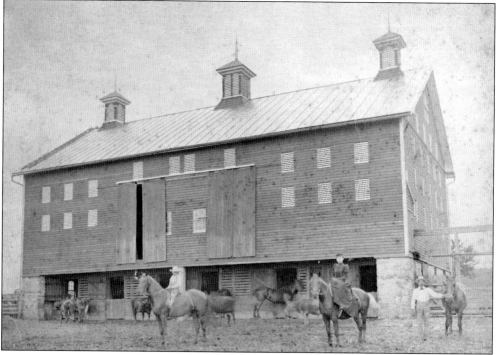

STACKHOUSE BANK BARN, 1895–1980S. Bank barns, such as this one that stood on the William Hammond Stackhouse farm in Poplar Springs, were very common in Howard County but were not built to last forever. From left to right, William Web, Virginia Stackhouse, and Augustus Riggs Stackhouse are pictured in front of the structure, which did not quite make it to its 100th birthday. (Courtesy Philip E. Stackhouse.)

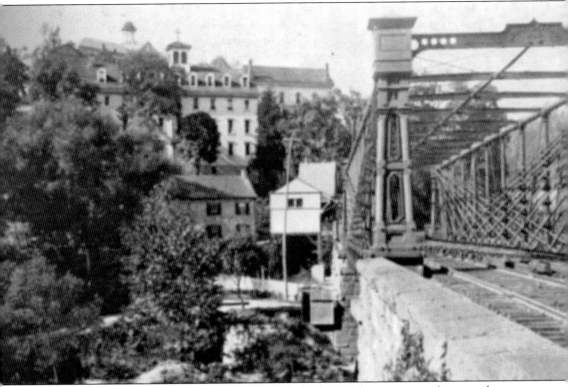

ILCHESTER, C. 1830s–1997. George Ellicott Jr., who built a combination stone house and tavern near the railroad tracks, founded Ilchester sometime after 1830. In 1866, Ellicott sold his cluster of buildings along with 110 acres to the Redemptorists order of the Roman Catholic Church, who built Mount St. Clemons College on the site. In 1882, the name was changed to St. Mary's College. The lower house of the college, which had incorporated the stone Ellicott house, was destroyed by fire on June 14, 1968. The massive upper house of the college, which towered over the Patapsco Valley for nearly 100 years, closed in 1972 and burned in 1997. Its ruins were demolished on February 13, 2006. The Bollman Truss railroad bridge across the Patapsco River was built in 1869, after the 1866 flood destroyed the Patterson Viaduct. It was replaced by another bridge around 1900. (Courtesy Philip E. Stackhouse.)

TALE OF TWO BRIDGES, 1870–1955. This c. 1910 photograph shows the two bridges that connected Howard and Baltimore Counties at Radcliff's Emporium in Ellicott City. The No. 14/No. 9 Line Electric Trolley Trestle Bridge opened on July 13, 1899, and was torn down after trolley service was discontinued in 1955. The 200-foot-long wooden covered bridge burned on June 7, 1914, when a cigarette carelessly tossed from a car ignited spilled gasoline. (Courtesy HCHS.)

THE "NEW BRIDGE," C. 1916–1972. After the covered bridge burned in 1914, a new concrete bridge had to be built for foot, wagon, and automobile traffic. This photograph, probably taken by a member of the Weld family from the grounds of Hazeldene/Lilburn around 1917, was labeled the New Bridge. It was destroyed in the Hurricane Agnes flood of 1972. (Courtesy the Weld-Keller family.)

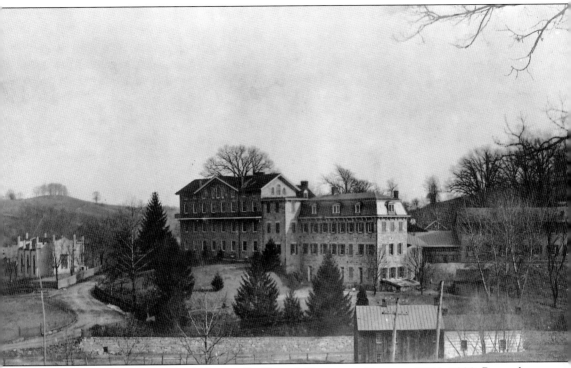

ROCK HILL COLLEGE, 1824–1923, AND ST. PETER'S EPISCOPAL CHURCH, 1854–1939. Begun by Isaac Sams in 1822 as Sams Academy for Boys, the complex of buildings known as Rock Hill College in Ellicott City was purchased in 1857 by the Christian brothers, who operated it until it burned on January 16, 1923. Stones from the ruins were used to build the Ellicott City High School on the same site in 1924. Built on the bluff behind St. Paul's Church across the street from Rock Hill College, the Gothic Tudor-style church known as St. Peter's Episcopal Church (far left) burned on Saturday, October 4, 1939, when a fire that began in the church furnace spread when sparks from the chimney blew onto the shingle roof. Rev. Julius A. Velasco called the fire department but because of low water pressure, there was little they could do. (Courtesy HCHS.)

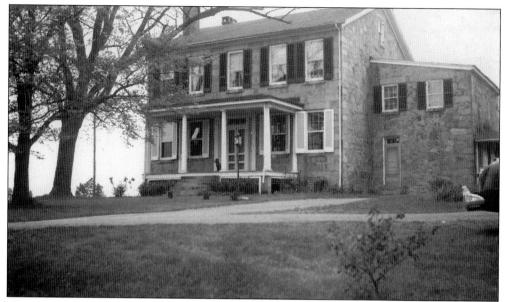

MOUNDLAND, 1846–1991. This fine stone home on Guilford Road in Simpsonville was built by Thomas Stewart in 1846 for his daughter Kate, who married Charles Griffith Worthington Jr. The interior featured original Cross and Open Bible–paneled doors, a 1830s Carpenter lock, Holy Lord hinges, and an outstanding staircase with a tulip poplar banister in the front hall. It was bulldozed to make way for the South Columbia Baptist Church. (Courtesy HCHS.)

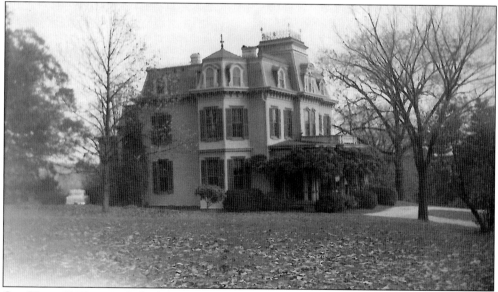

OAK HILL, 1875–1967. Rebuilt by Orson Adams in 1875, this Victorian Gothic home in Jessup stood on the site of a house that had burned. Originally known as Jessup's Cut, the town was named after Jonathan Jessup, a civil engineer who worked on the railroad. Home to six generations of the Adams family, in October 1967 the house went up "in a blaze of glory" that 40 pieces of fire equipment could not put out. (Courtesy HCHS.)

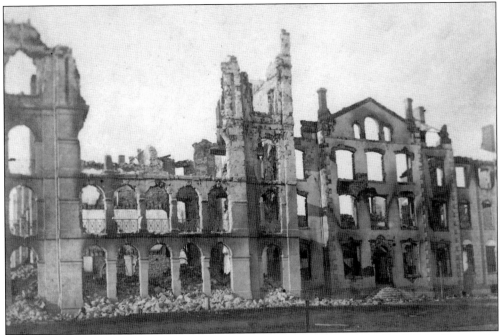

ST. CHARLES COLLEGE, 1831–1911. On the afternoon of March 16, 1911, Dr. F.X. McKenny, the president of St. Charles College, smelled smoke. Within 30 minutes, most of the college was in flames. Students and nuns had enough time to throw their belongings out the windows, but the priests lost everything. Virtually all of the college's manuscripts, paintings, and the nearly 20,000 books in the two libraries were lost. (Courtesy HCHS.)

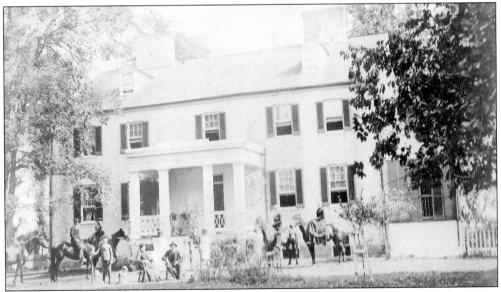

OAK HALL, 1809–1985. A Dorsey home since 1809, Oak Hall stood on a grant called New Year's Gift, given to Charles Carroll by Lord Baltimore. Once located on Oakland Road, this brick mansion had 19 rooms and nine fireplaces. Pictured is then owner and lifelong bachelor Larkin Dorsey, seated at a gathering in 1870. Oak Hall was demolished in November 1985. (Courtesy HCHS.)

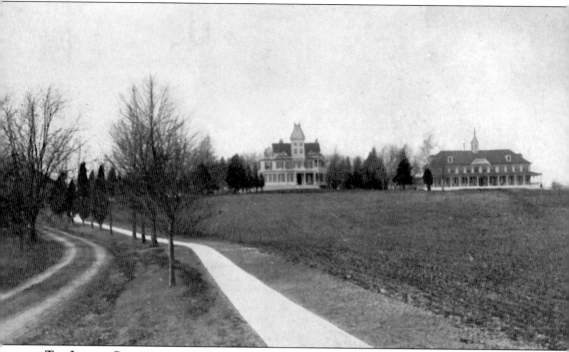

THE LAUREL SANITARIUM, 1905–1964. Established in 1905 by Jesse C. Coggins, this sprawling facility stood on a 163-acre tract in the area now known as Laurel Lakes. It was billed as a private hospital for the care and treatment of nervous and mental diseases as well as alcohol and drug addiction. In addition to 66 bedrooms, the five campus buildings offered such amenities as a gymnasium equipped with bowling allies, a billiard table, shuffleboard, a rowing machine, and other exercise equipment. The sanitarium employed a teacher to instruct women in needlework, raffia, basket making, and so on. In the men's group, patients were employed at gardening, road-making, and painting. Outdoor amusements included tennis, croquet, and ball-playing on grounds that were laid out with walks, lawns, gardens, and fields. Residents enjoyed meals supplied from the herd, poultry yards, and garden belonging to the institution. In 1964, the buildings were razed in a controlled burn, and the ruins were demolished in the 1970s. (Courtesy HCHS.)

ONE SPOT FLEA KILLER SIGN, 1930s–1960s. This roadside wonder was built by Willis Earl Simpson on land that he purchased in 1936 (located on the west side of Route 1, just south of Route 175). Created to advertise One Spot Flea Killer, which was manufactured nearby, this three-story cutout of a chow dog covered the north and south sides of a building and attracted attention until was torn down in the 1960s. (Courtesy Donald W. Reichle.)

HIGHLAND GARAGE, C. 1872–2004. Henry Timmerman built a blacksmith shop under a grove of oak trees on this site in the late 1800s. In the 1920s, Malcolm Disney turned it into a "modern garage" to service automobiles. It was known as Disney's Highland Garage into the 1950s. Later, the building was used for a variety of businesses, until it was torn down to make way for Highland Crossing. (Courtesy Mildred Disney Gallis.)

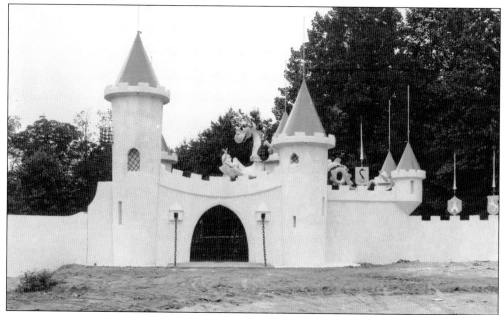

ENCHANTED FOREST, 1955–1995. After the Harrison family sold the park for $4.5 million to JHP Development in 1988, Enchanted Forest closed in 1989. It reopened the summer of 1994, after the shopping center was built. Between 1995 and 2005, the park was closed off behind a fence. Preservation efforts began in 1999 and have focused on moving the fairy-tale buildings to Clark's Elioak Farm. (Courtesy Linda M. Gardner.)

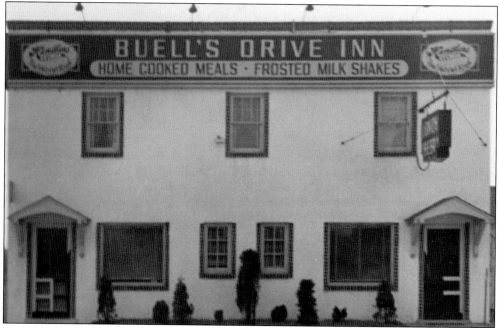

BUELL'S DRIVE INN, 1939–1992. When Buell's first opened in 1939, it was the only restaurant along Route 40 west of Baltimore. The home-cooked food came from the backyard, where the family had a garden and raised chickens and pigs. In 1992, Buell's became a Chinese restaurant called Uncle Y.Y.'s. The building was demolished to make way for a pharmacy. (Courtesy HCHS.)

About the Howard County Historical Society

The Howard County Historical Society serves as the primary private repository of historical records and artifacts related to Howard County's rich history, and the organization provides access for historical exploration, research, and discovery for all age groups. Our mission is to collect, preserve, and provide access to and public education about the history of Howard County through written records, documents, and photographs, and through three-dimensional cultural artifacts and oral history.

Our mission is furthered through the following: a commitment to excellence in maintaining and preserving the collections in our library and museum; an opportunity for, and support of, the public's engagement in research; a dedication to public access and education through our library and museum and exhibits and lectures related to the history of Howard County, along with workshops and other public opportunities for learning about Howard County history; the active involvement and energy of our membership in support of the work of the society; and our cooperation with all historical and preservation groups having a common interest.

For more information about Howard County history, please visit the Howard County Historical Society's archives at the Charles E. Miller Branch Library and Historical Center at 9421 Frederick Road, Ellicott City, Maryland, 21042, or our museum, which is located at 8328 Court Avenue, Ellicott City, Maryland, 21043. You may also follow us on Facebook, visit our website at www.hchsmd.org, e-mail us at info@hchsmd.org, or call us at (410) 750-0370.

DISCOVER THOUSANDS OF LOCAL HISTORY BOOKS FEATURING MILLIONS OF VINTAGE IMAGES

Arcadia Publishing, the leading local history publisher in the United States, is committed to making history accessible and meaningful through publishing books that celebrate and preserve the heritage of America's people and places.

Find more books like this at
www.arcadiapublishing.com

Search for your hometown history, your old stomping grounds, and even your favorite sports team.

Consistent with our mission to preserve history on a local level, this book was printed in South Carolina on American-made paper and manufactured entirely in the United States. Products carrying the accredited Forest Stewardship Council (FSC) label are printed on 100 percent FSC-certified paper.

MADE IN THE USA